IMAGES
of America

GREENPORT

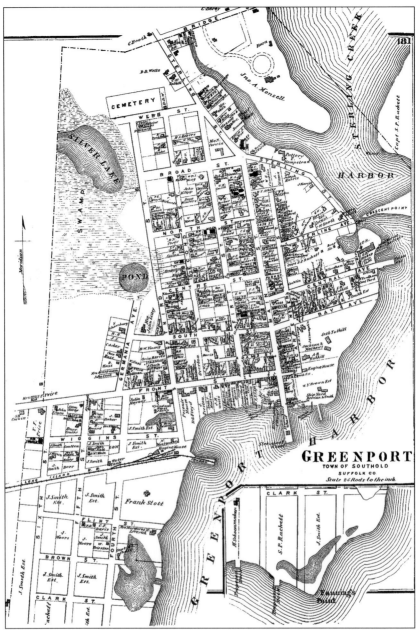

AN EARLY MAP OF THE VILLAGE. This old map of Greenport emphasizes the importance of the surrounding water to the development of the village and illustrates how Sterling Creek sheltered boats from the storm, earning the area the name of Winter Harbor. Main Street was laid out in 1827 to connect with the King's Highway, as the North Road was then called. A dock was among the first things built. The prosperity of the whaling era caused many businesses to cluster near the waterfront. Not surprisingly, these businesses included a ship chandlery, blacksmith, livery stable, shipyard, brickyard, doctor's office, and a watchmaker (who was also skilled as a jeweler). Caleb Horton built the first local ship, a sloop named *Van Buren*, in 1834. Henry Beebe erected the first house in the village when roads were still made of packed earth and sidewalks were rude planks laid over mud.

IMAGES
of America

GREENPORT

Antonia Booth and Thomas Monsell

ARCADIA
PUBLISHING

Published by Arcadia Publishing
Charleston SC, Chicago IL, Portsmouth NH, San Francisco CA

Printed in the United States of America

Library of Congress Catalog Card Number: 2003101271

For all general information contact Arcadia Publishing at:
Telephone 843-853-2070
Fax 843-853-0044
E-mail sales@arcadiapublishing.com
For customer service and orders:
Toll-Free 1-888-313-2665

Visit us on the Internet at www.arcadiapublishing.com

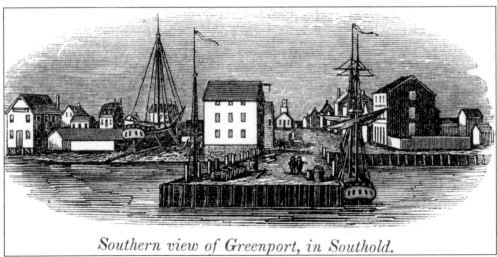

Southern view of Greenport, in Southold.

GREENPORT IN 1843. Greenport is shown in 1843, just a year before the village became the terminus of the Long Island Rail Road. Its excellent harbor and the population increase engendered by the railroad soon made Greenport the largest compact settlement in Southold. In 1845, according to Nathaniel S. Prime's history of Long Island, there were 12 ships employed in the whaling business.

CONTENTS

ACKNOWLEDGMENTS

We would like to thank Herb Adler; John Agria of North Fork Naturals, who scanned most of the photographs in our two shows; Judy Ahrens, who allowed us to use her photograph of the Greenport Water and Electric plant from the *Suffolk Times*; architectural photographers Steve and Gil Amiaga; Bruce Bollman; Whitney Booth; Courtney Burns and the Oysterponds Historical Society; Mike Caprise; photographer Michael Cody; Lee Cleary; Chris Conway; Virginia Mitchell Cornell; David Corwin; Penny Coyle; Carlos de Jesus; Tony Dobek; Van R. Field; the Floyd Memorial Library; Regina Straussner Gargani; Craig Geier; Alex Giorgi; Helen Cowan Grigonis; Gail and Dave Horton; Josephine Watkins-Johnson; Rita Hagerman; Christine Hascoat; Jim Heaney; Helene Horne; Charlotte Jorgensen; David Kapell; Eileen Kapell; Ida Kaplan; Micah Kaplan; Joel Lauber; Richard Leahy; Charles Meredith; Doug Shaw of the Long Island Maritime Museum; Joey MacLellan; Venetia McKeighan; James Monsell; Capt. "Bo" Payne; Mike Richter Photography; Denise Ross; Audrey Rothman; Sherwood Rouse; Barbara Rudder; Jack Sherwood; Connie Solomon; the Southold Historical Society; the Whitaker Collection of Southold Free Library; Peter B. Stevens; Brian and Dewey Sullivan; Joe Townsend Jr.; Joan Tyrer and the Clive Tyrer Collection; and Brad Wiley. No doubt we have forgotten to acknowledge someone who has helped. For this we apologize.

INTRODUCTION

Like any working seaport worth its salt, Greenport has clung tenaciously to its shoreline, the sine qua non that has made it what it was, what it is, and what it will be despite the vagaries of current culture. Our forebears had the wisdom to follow nature and let it provide for them in many lucrative ways: shipbuilding, oystering, whaling, and commercial and recreational fishing. The farcical melodrama involving bootleggers and rumrunners cannot be overlooked either. During World War II, our maritime resources were used for higher purposes, as hundreds of defense workers produced minesweepers for the U.S. Navy. The feeling of patriotism was overwhelming, as was the excitement of having celebrities like songbird Kate Smith and diva Lily Pons come to Greenport to christen the minesweepers. In true Greenport fashion, not only stars but also local high school girls were asked to crack a bottle of champagne against the bow of the new ships.

Early Greenporters valued their environment and had a strong streak of independence and innovation as well. By 1898, Greenport had established its own municipal electric power plant—the only such facility in Suffolk County. A notable demonstration of innovation was the creation of the "Picket Patrol," also known as the "Hooligan Navy," a ragtag bunch who, in their own small wooden sailboats, wanted to do their bit early in World War II by surveilling the Atlantic for German U-boats and saboteurs. They found some, too, and they radioed the location to the Coast Guard. Their home port was Greenport, their home base the venerable Booth House, and their homes away from home the bars at Claudio's and Mitchell's.

In the 1660s, long before the Hooligans and World War II, the area that became Greenport was a vast expanse of land known as the Farms, owned by Col. John Youngs, son of the first minister of Southold. The region bordering Sterling Creek was called Winter Harbor because it seldom froze over. Three lines from the 1850 poem "Greenport," by John Orville Terry, vividly bring that harbor to life:

> Five hundred ships may safely ride,
> abreast her green, ascending side,
> and storm and wave defy. . . .

Late in the Colonial period, the village was called Stirling, or Sterling, after the Scottish earl of Stirling, who was the original recipient of land from the British crown. Incidentally, a descendant of the earl fought on the American side in the Revolutionary War and became one of George Washington's most trusted generals and closest friends.

After the American Revolution, the area, which had considerable marshland and a rise near the present-day Greenport Yacht and Shipbuilding Company, became known as Green Hill, or Greenhill. At the beginning of the 19th century, the hill was leveled and its earth was used to fill in marshy spots in what became the village's commercial area. A community meeting on June 28, 1831, decided that since Greenhill no longer had a hill and the settlement was really a working seaport, the name Greenport was more appropriate. During the mid-1800s, the poet Walt Whitman was a frequent visitor to the newly named village and wrote glowingly of it. Whitman's sister, Mary Elizabeth Van Nostrand, lived near the corner of Third and South Streets.

As time passed and the village prospered, residents thought it wise to incorporate. The public wanted a self-sustaining local government, and in 1838, a meeting was held at which a resolution for incorporation passed handsomely. In 1988, after 150 years of lively and turbulent politics, a celebration was held at the American Legion Hall for hundreds of Greenporters and their friends. Coincidentally, that hall was the site of the grand party held in 1844 to celebrate the arrival of modern life in Greenport in the form of the Long Island Rail Road. Such celebrations illustrate Greenport's historically high community spirit and love of a party. The village still likes to party, and with all the fine restaurants, art galleries, and boutiques added to the mix, Greenport has become an even more vibrant place that still retains its earthy and embracing charm.

My contributions to this book are dedicated to my husband, Whitney, who supports and sustains me in everything I do, and to our dear children and grandchildren.

—Antonia Booth

I dedicate my efforts in the creation of this work to my three brothers: George, who is a seeker of knowledge; James, who is my idea of the ideal public servant; and Richard, who died at 21 before having savored the wine of life.

—Thomas Monsell

One

STERLING DAYS

THE ROAD TO GREENPORT. Mill Creek is pictured before the present bridge to Greenport on the Main Road (Route 25) was built in 1925. Even before the town of Southold was founded in 1640, adventurers from the West Indies and North Carolina came to this area for the lofty oak trees, used for masts and barrel staves; the tall pines, used to make turpentine; and the fine clay beds, used for brickmaking. What is now known as Mill Creek was first called Thomas Benedict's Creek, later shortened to Tom's Creek.

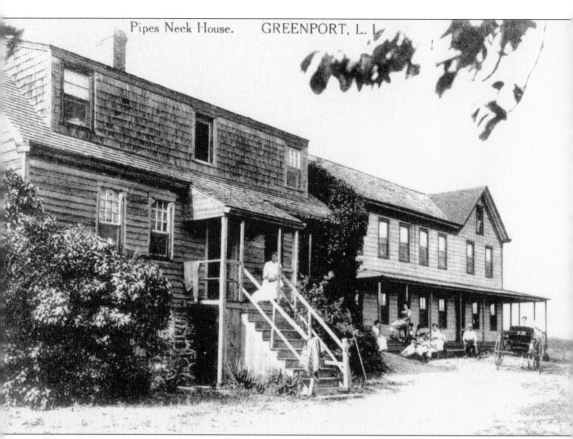

Pipes Neck House. GREENPORT, L. I.

THE WEST INDIES TRADE. The greater Greenport area was settled by Englishmen coming from the West Indies. As early as 1638, the first house in the area was erected by Richard Jackson, who sold it to Thomas Weatherly on October 25, 1640. Timber cut nearby was used for making barrels for sugar and whale oil. In the 19th and early 20th centuries, there were two Pipes Neck houses inhabited by "merry crowds of young people who spent considerable money in Greenport." The first house, built in 1823, burned down in 1912.

A BIT OF GREENPORT.

"A BIT OF GREENPORT." Settlement of the village by "a few spirited people" did not begin in a serious way until 1827. However, Greenport was soon "the most populous, compact, and prosperous village in the town," according to lawyer Benjamin F. Thompson's 1843 *History of Long Island*. Thompson's study went on to say that the village was laid out in a regular manner, that there were already 100 dwellings, and that there were 700 inhabitants. Some of the many ships operating from Greenport Harbor were engaged in the coastal freight trade. Others were whalers, among them the *Delta*, *Potosi*, *Bayard*, *Neva*, *Caroline*, and *Sarah Esther*. A much more complete list of whaling vessels operating out of Greenport from 1795 to 1858, compiled by Walter Mengeweit of Southold, appears in the winter 1985 issue of the *Register*, a publication of the Suffolk County Historical Society.

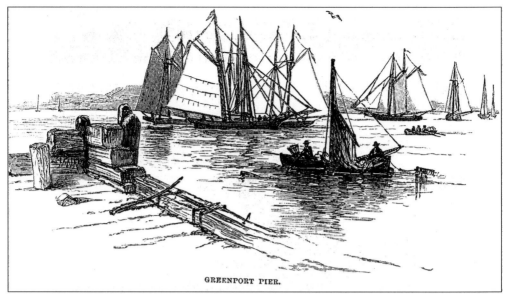

GREENPORT PIER.

THE GREENPORT PIER. This early sketch of Greenport shows the harbor full of sailing ships and vividly portrays the volume of trade the village attracted from all over the world. Until 1838, when a wharf was built at the foot of Central Avenue, all cargoes landed at the wharf on Stirling Creek. The surveyor of the port of Greenport registered 228 sailing vessels soon after the incorporation of the village.

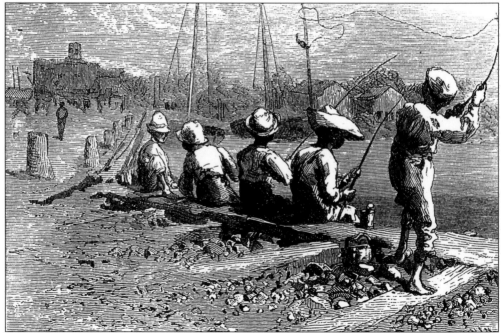

NEAR THE DOCKS—PASTORAL YET BUSY. Walt Whitman, a frequent visitor to the village, praised its "handsome" situation and wrote that it was "unsurpassed for health." A transportation hub, Greenport had many hotels within walking distance of the docks where steamboats made regular calls, and the rail station could be reached in a few minutes. Good fresh food and good fishing are still available in Greenport.

LONG ISLAND RAIL ROAD COMPANY,

SPRING ARRANGEMENTS,
To commence April 2d, 1849.

FROM BROOKLYN,

From Brooklyn, at 8 A.M., through freight,
Do. 9 1-2 A.M., passenger,
Do. 12 M., Farmingdale, passenger,
Do. 4 P.M., Yaphank, passenger,
Do. 6 1-2 P.M., Jamaica, passenger, (this train will stop to land and receive passengers at any place between Brooklyn and Jamaica.)

TO BROOKLYN,

From Greenport, at 8 A.M., through freight.
Do. 9 1-2 A.M. through passenger,
From Yaphank, at 5 1-2 A.M., accommodation passenger,
Do. 11 18 A.M., through passenger,
Do. 11 35 A.M., through freight,
From Farmingdale, 7 A.M., Yaphank accommodation passenger,
Do. 12 40 P.M., through passenger,
Do. 2 24 P.M., through freight,
Do. 4 15 P.M., accommodation passenger,
From Jamaica at 7 A.M., Jamaica, passenger, (this train will stop to land and receive passengers at any place between Brooklyn and Jamaica.)
Do. 8 A.M., Yapank accommodation,
Do. 1 45 P.M., Greenport accommodation.
Do. 4 10 P.M., Greenport freight,
Do. 5 15 P.M., Farmingdale passenger.

RATES OF COMMUTATION.

		Three months.	Six months.	Twelve months,
From Brooklyn and all intermediate places to Jamaica, each person,	$16		$30	$50
Do.	to Farmingdale,	20	36	60
Do.	to Yaphank,	25	40	65
Do.	to Riverhead,	30	45	70
Do.	to Greenport,	35	50	75

No Freight taken on the passenger trains.

DAVID S. IVES, Superintendent.

AN EARLY TRAIN SCHEDULE. On June 27, 1844, the first train came through Greenport, the cause of a grand celebration. People came from all over, and there were many toasts with French champagne. A small party of Shinnecocks, from across Peconic Bay, attended. The rail line was originally planned as a link from New York to Boston. Thus, a Greenport boat met the train and ferried the passengers back and forth between Stonington, Connecticut, and the village. Alas, the first railroad was a failure, and by 1850, it was in the hands of a receiver. The original survey for the railroad put the terminus near Horton's Point, but a curve was later added east of Peconic to put the tracks on a course straight through the center of Southold and on into Greenport. The North Fork line preceded the Montauk Division by 26 years.

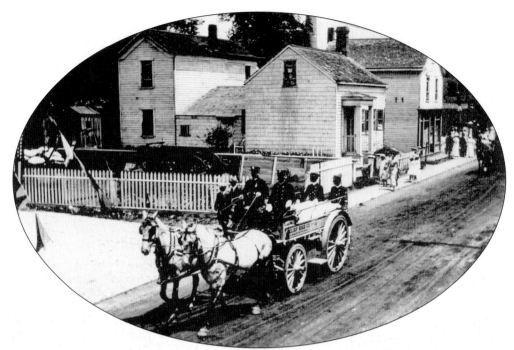

THE RELIEF HOSE COMPANY. The wagon of the Relief Hose Company is pictured at center, with South and First Streets just behind the women dressed in white. The shop on the corner is Webb's Meat Market, with the icehouse in back. Webb's is now the Center for Integrative Health Care, and the area on the left is Community Action Southold Town.

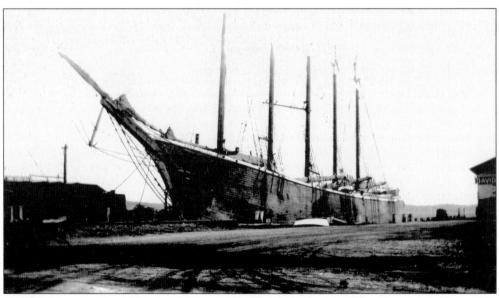

THE LAST OF THE FIVE-MASTED SCHOONERS. The coal schooner *Edna Hoyt* was built in 1920 by Dunn and Elliot of Maine and owned by the Superior Trading and Transportation Company of Boston. The schooner, weighing 1,512 tons (1,384 under deck), is shown at the dock in Greenport. The ship was listed in the 1925 edition of *Merchant Vessels of the United States,* as well as in the 1936, 1937, and 1938 editions of *Lloyd's Register of Shipping.*

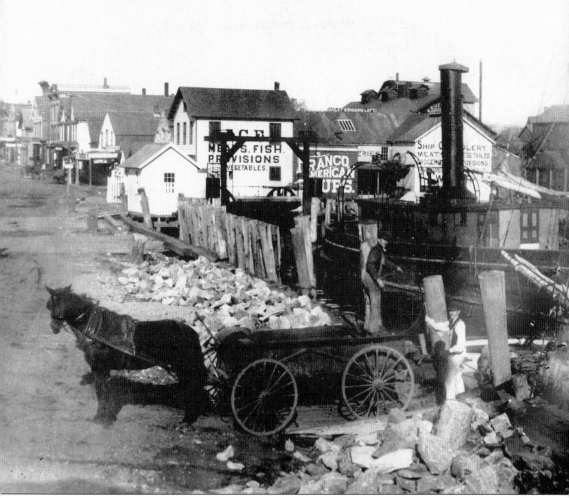

REBUILDING THE BULKHEAD, LOWER MAIN STREET. Clive Tyrer was not only a collector of local pictures but was also a pilot who, for 35 years, worked spotting schools of menhaden, or bunkers, from the air for fishing companies whose fleets tied up at the Greenport docks. When gathered into a school of up to a mile long, these bluish fish gave off a "deep red sheen," according to Capt. Kenneth "Bo" Payne. The high point of the industry, Payne said, was from the 1850s to the mid-1900s. The Report of the Commissioners of Inland Fisheries, which outlined the history of the industry in 1880, quoted from a fisherman's diary dated as early as 1793 that made reference to menhaden fishing. Used as fertilizer, the fish were caught in short draw seines woven by farmers' wives of flax grown on local farms. (Courtesy Tyrer Collection.)

AN EARLY ACTIVIST. Eva Albertson Horton was one of several early feminists in the village. Active in the Temperance movement, she also campaigned for a woman's right to vote. In her 70s, she wrote a column for the *Riverhead News*. Her father was commissioned a major during the Civil War, and she spent some time with him in Washington, D.C. Her husband, Schuyler Bogart Horton, was a funeral director. During the Spanish-American War, he had a contract to pick up the bodies of soldiers who died at Camp Wyckoff, in Montauk.

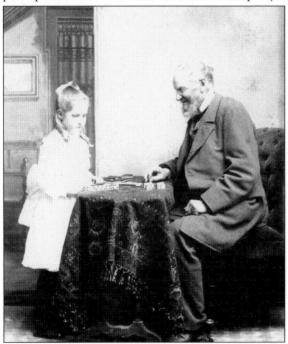

PLAYING DOMINOES. David Gelston Floyd and a young relative play with a set of dominoes in the late 19th century. Floyd was a successful investor in whaling ships. In 1851, he built the mansion Brecknock Hall, now the centerpiece of Peconic Landing, on the North Road in Greenport. Floyd Memorial Library is named after him. His grandfather William Floyd signed the Declaration of Independence.

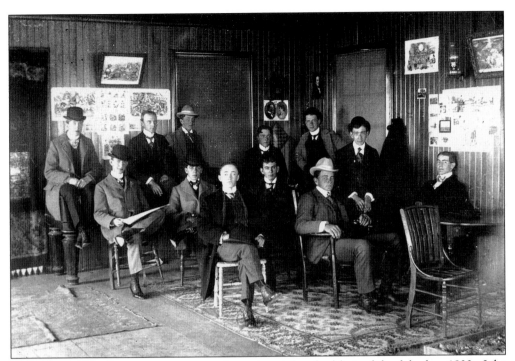

SAY CHEESE. The Portsonians was a gentlemen's social and athletic club of the late 1800s. Like so many people in vintage photographs, the club members, when dressed formally, apparently felt they were forbidden to smile. This was the era of the clubhouse, and hence a multitude of social organizations and discussion groups for men and women flourished in the village of Greenport.

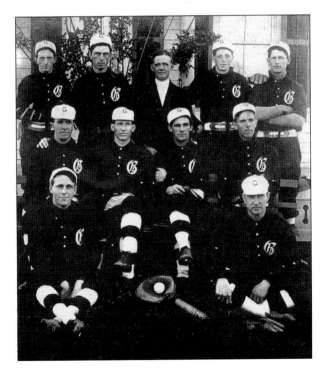

THEY HAD GRAVITAS. These members of the 1907 Greenport Baseball Club took the sport seriously. In those pre-television days, local sports were more important than they are today. The Stirling Athletic Club was founded in 1884 at the rear of John Geehreng's tin shop, on Main Street. John Geehreng, known as the Flying Dutchman, was elected president for 15 terms.

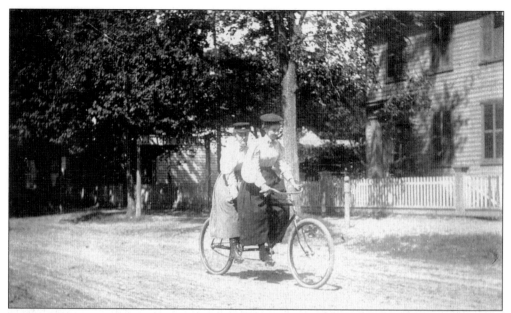

BICYCLE BELLES ON A TANDEM. "Bicycle bells ring continuously as jolly girls and boys meet," read a headline in the *Suffolk Times* in 1894. Bicycle races were a popular Sunday afternoon sport. Often, in warm weather, Main Street would be closed between Claudio's and the North Road for an afternoon of bike riding and flirting.

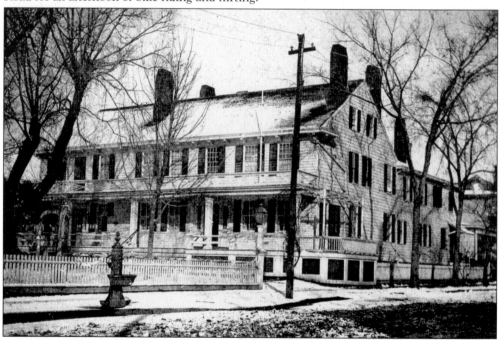

YE CLARKE HOUSE. Greenport's hotel opened in 1831. It was built by Capt. Caleb Dyer of Orient for Capt. John Clarke, whose father was a soldier in the Revolutionary War. Captain Clarke and his wife, the former Maria Davis, intended the hotel to serve the needs and wishes of whaling captains, officers, and ship owners. When the whaling industry declined, the hotel became a popular summer resort with a post office in its basement.

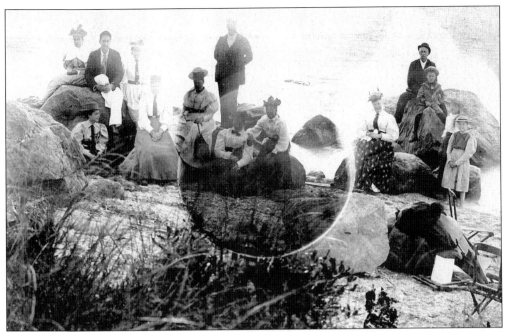

"Fond Recollection Returns Them to View." This 1890 view shows a multigenerational family picnic at the foot of Greenport's 67 Steps. To the far right, sitting on a boulder, is S.B. Horton, and perched on a rock in front of him is future town supervisor S. Wentworth "Skipper" Horton, who was about five years old at the time. Present-day partygoers are not as stylishly dressed.

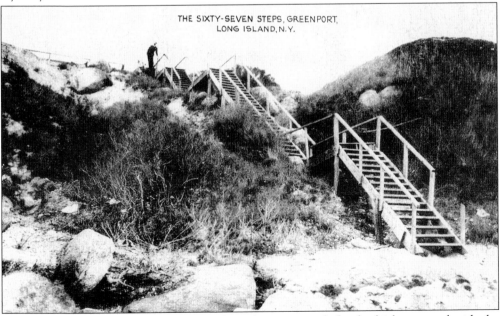

THE SIXTY-SEVEN STEPS, GREENPORT, LONG ISLAND, N.Y.

Not Exactly 67. At the end of Sound Road, a staircase links the higher ground with the beach, a traditional place for Greenporters to picnic. The number of steps has varied over the years due to erosion, but the name has remained the same. The staircase is still known as the 67 Steps.

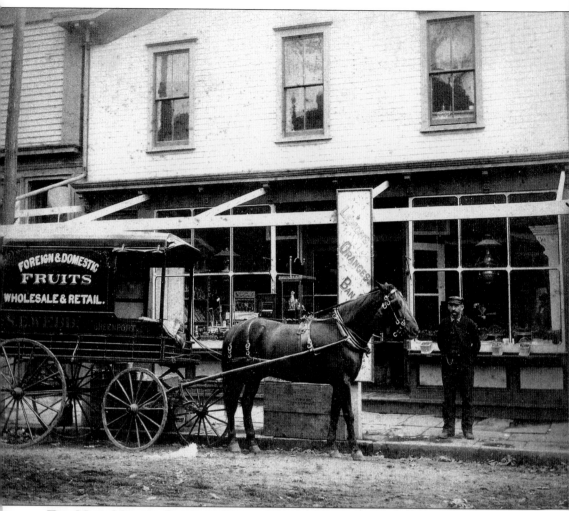

THE MOST MODERN STORE IN TOWN. Imagine having the groceries delivered—and such groceries: no other store regularly stocked exotic fruits like bananas, oranges, and lemons. The name Webb is a very early one in the village. Silas Webb began as a real estate speculator *c.* 1820, when he purchased a large tract of land on Sterling Basin, divided the land into lots, and began to sell the lots at a profit. In 1868, David Webb, who lived at the corner of Front and Main Streets, had a grocery store at the foot of Main Street. Later, the *c.* 1910 census of Greenport (*Lawton's Southold-Shelter Island Register*) lists a David Webb, who had a butcher shop on Front Street, and a brother, Edward M. Webb, who operated a grocery business on Germania Avenue (now Fourth Avenue). The village has always had a wide range of food shops to supply provisions to ships and for summer visitors.

Two

THE SOUND OF THE SEA

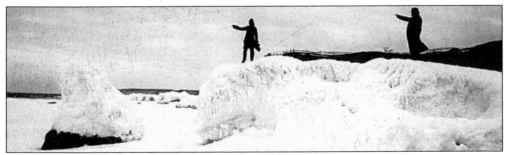

ICY LONG ISLAND SOUND. Eastern Long Island has been the scene of many epic storms. *Griffin's Journal*, published in 1857, relates that in the year 1816, each one of the 12 months had frost. This photograph may have been taken in the winter of 1917–1918, when people walked between Shelter Island and Greenport, and the North Sea (as Long Island Sound used to be known) was almost frozen over.

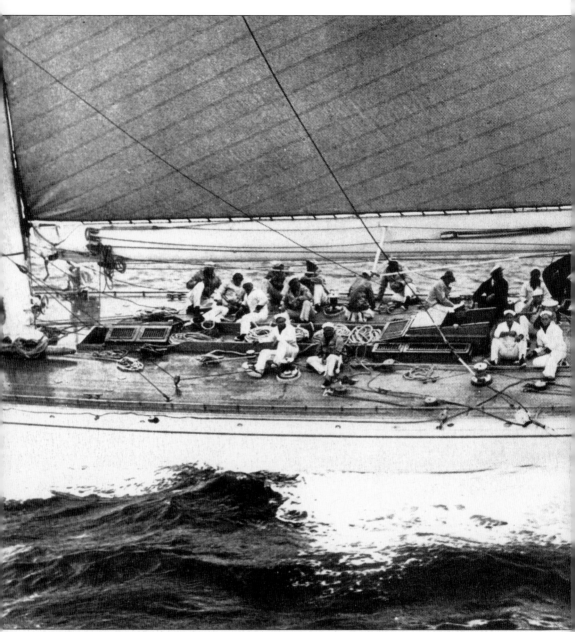

THE AMERICA'S CUP DEFENDER. The *Rainbow*, winner of the America's Cup race in 1934, is shown during trials at Newport. Owned by Harold Vanderbilt, the racing schooner yacht was captained by a Greenport man, George Hiram Monsell, and fitted out in the village. Most of its crew was from Southold and Greenport. Additional national cup defenders with the same local connections were the 1930 champion *Enterprise* and the 1937 champion *Ranger*. The *Bystander*,

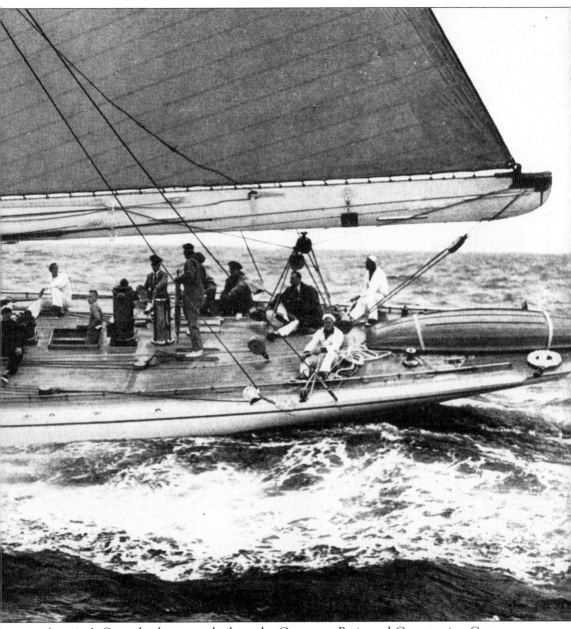

an America's Cup pilot boat, was built at the Greenport Basin and Construction Company. After the 1934 victory, an enormous celebration was held at the Metro Theatre, on Front Street in Greenport, attracting many celebrities and politicians. The captain, George Monsell, was inducted into the Suffolk County Sports Hall of Fame in 1995.

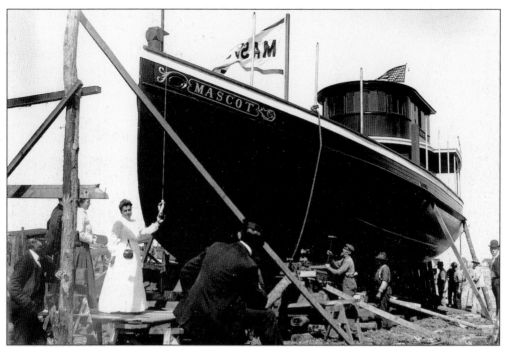

THE CHRISTENING OF THE MASCOT, 1906. This oyster boat was built for the Cedar Island Oyster Company and was acquired by the Mills Company of Greenport. Prior to 1906, most oyster boats were converted schooners. The *Mascot* was one of the first actual oyster boats. It was built at the Terry and Thorne Shipyard, which later became Sweet's Shipyard and, more recently, the Stirling Cove Condominiums.

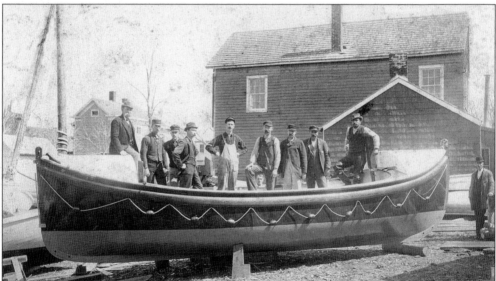

LIFESAVERS. In their shop at the foot of Ludlum Place, Frederick Chase Beebe and Capt. C.H. McLellan designed and constructed a lifesaving boat that was awarded a contract from the U.S. Life-Saving Service. For more than 30 years beginning in the 1880s, these boats were sold throughout the world. A 1903 report stated that the boats had been launched 6,730 times and rescued 6,735 people from shipwrecks.

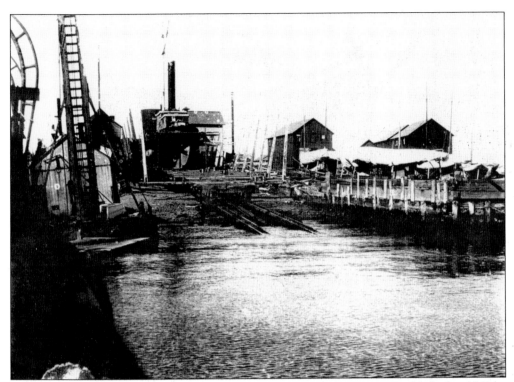

THE WAYS AT THE GREENPORT BASIN AND CONSTRUCTION COMPANY. Established in 1863 by Henry Mulford, Charles Smith, and Emmet Ketcham, the name of the shipyard was changed in 1878 to Smith and Berrian and later to Smith and Terry. With more than 500 feet of waterfront, the basin could hold 150 good-sized craft. C. Pliny Brigham purchased the company and added a new set of ways, as well as a wharf with a bulkhead extending to the harbor line.

A SOUND FREIGHTER. The *George F. Carman* was a coastal freighter owned by Capt. James Monroe Monsell. Its business was carrying farm produce up and down from Greenport to New Haven, Connecticut, Providence and Newport, Rhode Island, and Boston and other ports along the New England coast. It also carried wood and granite for house foundations. Monsell's home was on Fourth Street on what is now Andrew Levin Park.

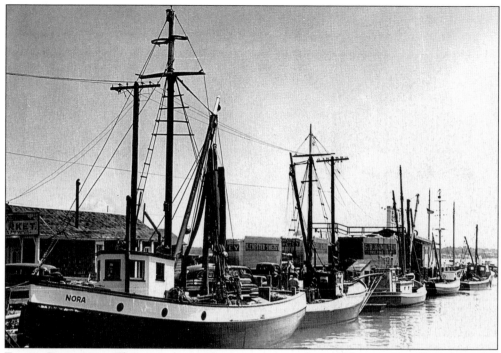

FAMILY BUSINESSES. This typical waterfront scene shows late-1930s cars, Terrell's Fish Market (left), and a string of fishing boats (foreground), the first of which is the *Nora*, owned by the Fiedler family. Hayes's dock (right) became home to Crabby Jerry's seafood restaurant. Bandleader Guy Lombardo sometimes participated in speedboat races in the open area beyond the dock.

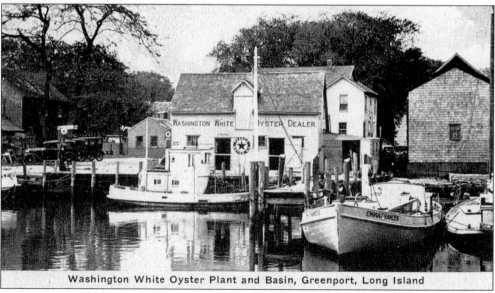

Washington White Oyster Plant and Basin, Greenport, Long Island

EARLY LOCAL FAMILIES. This early-20th-century view shows the Washington White oyster plant in Rackett's Basin (now the site of the Stirling Cove Condominiums). The White family long operated Washington White's hardware store on Main Street, and the Racketts were prominent in East Marion and Orient, as well as in Greenport.

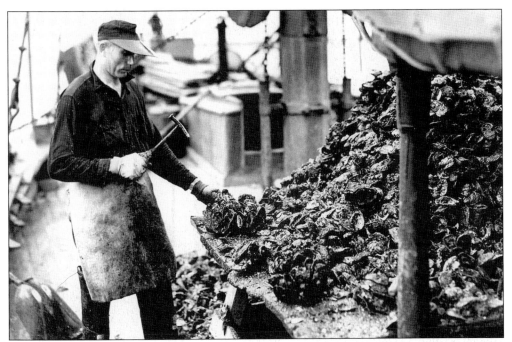

OYSTER PROCESSING. The oyster clusters are broken in order to process them. At its height, the oyster industry had 14 companies operating in Greenport. Huge piles of oyster shells dotted the waterfront. Many of these shells were used in driveways and roadbeds. Oyster shells are soft and crumble under pressure, while clamshells remain sharp and can cut tires.

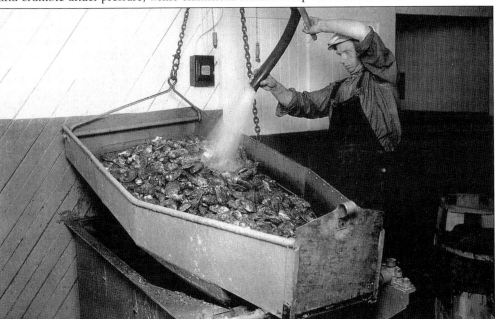

OYSTERS AND THE ECONOMY. The magnitude of the oyster industry's contribution to the local economy cannot be exaggerated. Almost 100 percent of the oyster harvest came from cultivated beds and required a heavy investment in boats, packing equipment, marketing, and refrigeration, according to Paul Bailey's 1949 book *Long Island: A History of Two Great Counties*.

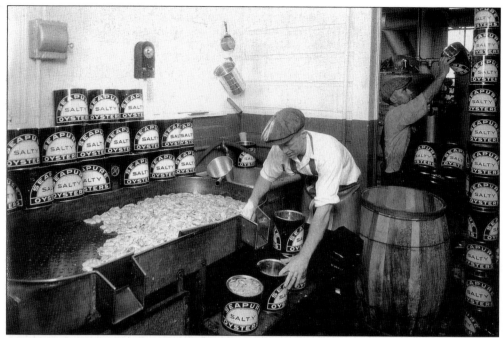

PACKING OYSTERS. At the end of the 19th century, oysters were so plentiful and cheap they were eaten by the working class, as well as the gentry. By the 1930s, when these pictures were taken, overfishing and pollution had markedly cut the yield from the oyster beds. A scientific approach to oyster farming and cultivation prevailed at Greenport's oyster plants, and great care was taken to keep oysters fresh and attractive for city markets.

THE HYGEIA ICE COMPANY. David C. Petty managed this ice business, as well as a saloon on Main Street. Ice was not only important for preserving household food but also vital to the fishing industry, allowing much more of the catch to be sold. Before electric refrigerators were common, ice was cut from Silver Lake in Greenport and Marion Lake in East Marion, packed with hay and sawdust, and stored for months.

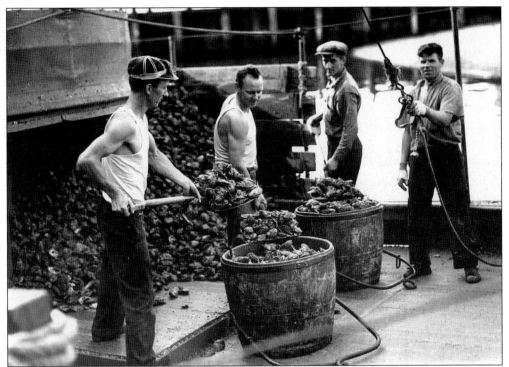

UNLOADING OYSTERS FOR THE PROCESSING PLANT. Greenport was the center of the oystering industry on eastern Long Island because of its deepwater harbor, many repair yards, access to the railroad, and marine supply stores. Railway Express shipped countless barrels to New York and Brooklyn restaurants during the oyster season.

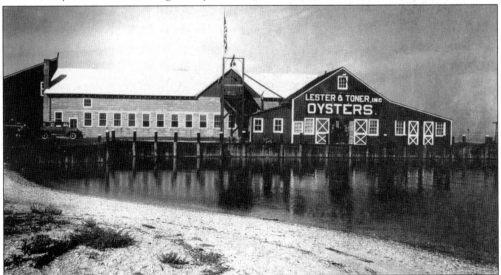

THE LESTER AND TONER OYSTER COMPANY. Lester and Toner, on Fifth Street, is now the site of the Oyster Point Condominiums. "In 1884 the State of New York deeded to the Suffolk County Oyster Commission the land beneath the waters of Peconic and Great South Bay to be sold to applicants who would use it for the cultivation of oysters," according to Elsie Corwin. "Captain James Monsell, an experienced bayman, was the first engaged in dredging in Peconic Bay."

THE PROMISED LAND. Several Greenport families had oil and fertilizer factories, also known as bunker factories, in the western area of the Montauk peninsula known by this biblical name. The Montauk factories included the Ragged Edge Oil Works of Ellsworth, owned by Tuthill and Company; the Ranger Oil Company, owned by T.F. Price and Company; and the Falcon Oil Works, owned by George T. Tuthill and Company.

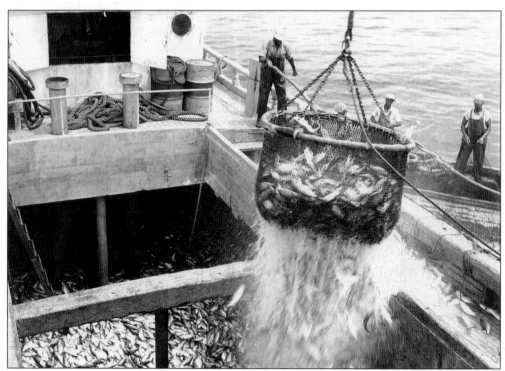

RAISING THE NET. The first recorded catch of the moss-bunker, or menhaden, in local waters was by Ezra L'Hommedieu in 1795. Since then, many uses have been found for this oily fish: fertilizer, animal feed, and paint ingredient. Menhaden fleets, one of the village's greatest seasonal economic boons, berthed in Greenport for decades.

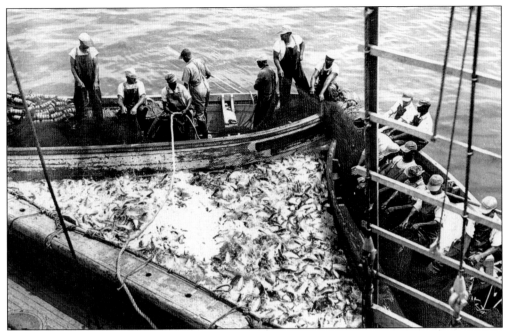

An Enormous Catch. A net teems with menhaden prior to loading and processing. For a long time, bunker fishing fueled the local economy. "Menhaden fishing is what saved Greenport from the same fate as other whaling towns," according to journalist Dan Horton. The fish are still used in a variety of commercial products. The smell of the fish being processed, although not necessarily pleasant, has been likened to "the smell of money."

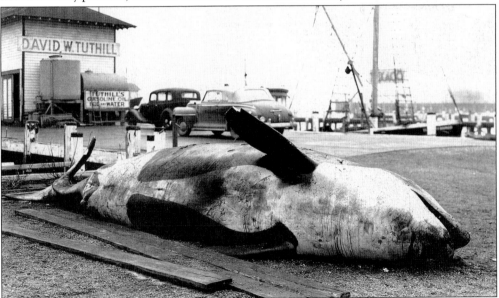

A Killer Whale. This six-ton whale somehow beached itself at Orient in January 1944. Local fishermen towed it to Tuthill's Dock, where it served as a great attraction for several days. Eventually, a scientist from the Cold Spring Harbor laboratory came to the village and carved off the whale's head and took it back for research. The rest of the mammal was towed to the bay and allowed to drift away.

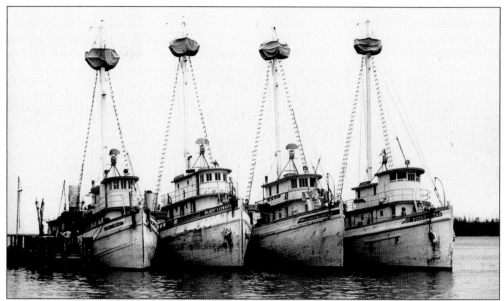

THE 1960S CHANGED IT ALL. Part of the famous bunker boat era, the dock at the Greenport Basin and Construction Company was active until the early 1960s, when bunkering died out because of overfishing, pollution, and the so-called "brown tide." The growth of tourism and second-home ownership drove the fish factories with their unpleasant odor off the North Fork to an uninhabited strip of land on the South Fork. (Courtesy Tyrer Collection.)

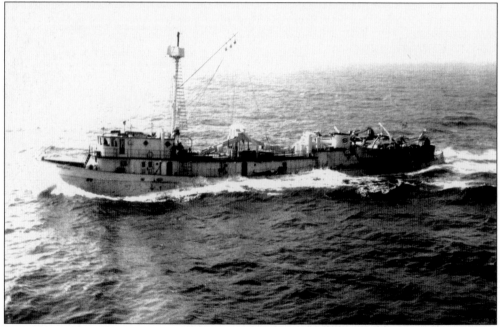

THE NAPEAGUE. This was one of the newer, faster, steel 1,000-horsepower diesel boats that plied local waters in the second half of the 20th century. The *Napeague* was built in 1955 by RTC Shipbuilders of New Jersey. Prior to 1949, the bunker fleet consisted of wooden ships. The boats were serviced by Brigham's Shipyard, later Stephen Clarke's Greenport Yacht and Shipbuilding. (Courtesy Tyrer Collection.)

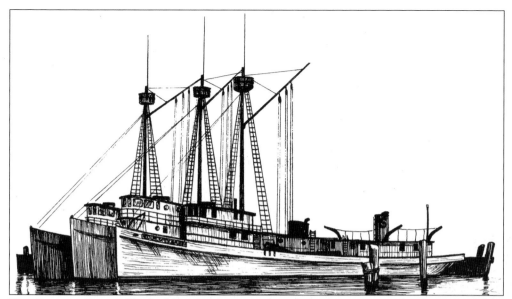

THE BUNKER FLEET. Shipbuilding has been important on eastern Long Island since Colonial times. Ship's carpenters constructed many of the oldest houses. In the 19th century, Suffolk County had at least 25 shipyards. Changing times and improvements in other forms of transportation made shipyards less important. As long as there is commercial fishing, however, the yards will be necessary for repairs to existing ships.

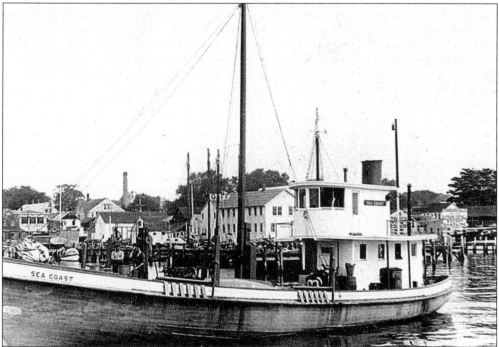

POWERED BY A GAFFGA ENGINE. At 50 feet long, the *Sea Coast*, owned by the Sea Coast Company of New Haven, was larger than most oyster boats. Its powerful engine was made in Greenport at the Gaffga Engine Works (background), which was known worldwide for designing, manufacturing, and repairing engines.

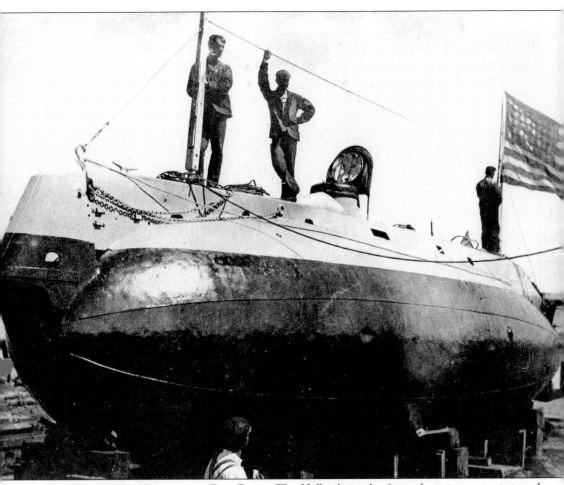

THE SUBMARINE HOLLAND AT DRY DOCK. The *Holland* was the first submarine commissioned by the U.S. Navy. Its inventor, John Philip Holland, was a schoolteacher from Ireland who came to America in 1872. He had already developed plans for an underwater ship. After many disappointments, the Holland Torpedo Boat Company established a base in New Suffolk "for the development, fitting and trials along with other submarines of the same class." Clara Barton, founder of the American Red Cross, was a passenger on one of the trial runs of the 53-foot-long boat. Trials were continued in Greenport until 1905, when the submarine base was moved to Groton. According to Marjorie Moore Butterworth's 1983 book *The New Suffolk Story*, the *Holland* was sent to the Washington Navy Yard and then to Newport, where the navy crew was trained. It was dismantled for scrap in 1930, but several of Holland's other submarines have been preserved.

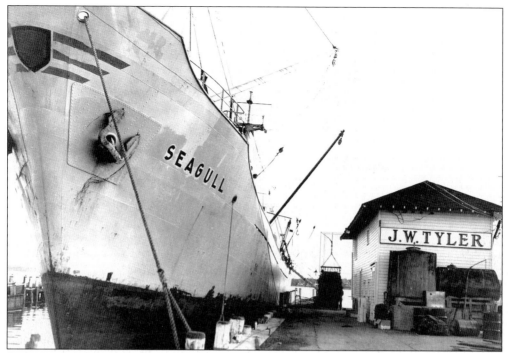

JAKE TYLER'S DOCK. At the dock, the coastal freighter *Seagull* takes on fuel for the return trip. J.W. Tyler held the Mobil franchise for the East End of Long Island. Each spring, large freighters brought seed potatoes from Prince Edward Island to Greenport for local farmers to plant. Tyler was a Greenport village trustee. The dock later became Claudio's dock.

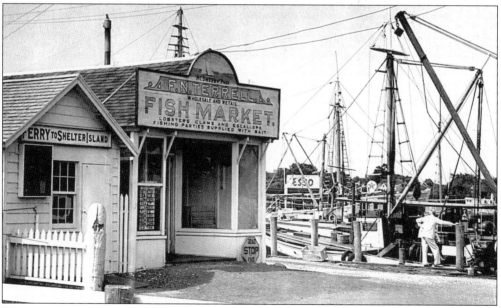

WAITING FOR THE FERRY. Until 1958, the Shelter Island ferry had two docks: one at lower Main Street (shown) and the other at the Long Island Rail Road dock. Traffic increased so much that business owners were upset because their customers had no place to park. The ferry company finally moved its entire operation to the railroad dock.

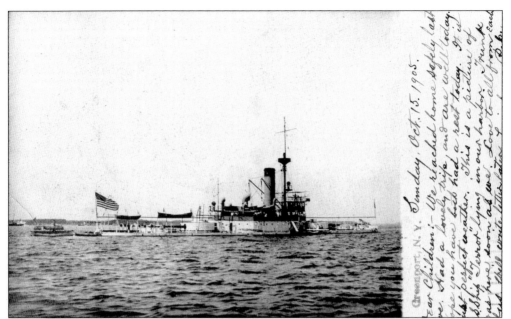

Greenport, N.Y. Sunday Oct. 15. 1905. Dear Children:- We reached home safely last ... Had a lovely trip and are well today. ... you have had had a rest today. It is ... perfect weather. This is a picture of ... Ship "Terrot" lying in our harbor. ... here down and we ... Love to all from each ... and this week illumination ...

THE USS TERROR. An armored monitor BM-4 is shown in Greenport Harbor in 1905. The *Terror* was commissioned in 1896 and spent its first two years operating off the East Coast. During the Spanish-American War, the *Terror* was active in the West Indies. From 1901 to 1905, it was used as a training ship for the U.S. Naval Academy.

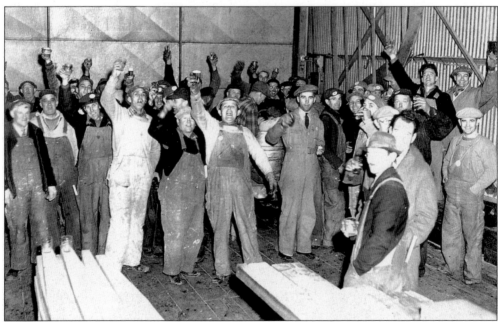

WIVES, MOTHERS, SWEETHEARTS, AND CELEBRITIES. Workers celebrate the completion of another vessel. During World War II, many different women helped launch minesweepers and tank lighters at the Greenport Basin and Construction Company. By July 1942, a total of 31 vessels had been launched. Many workers left defense work at the yard and enlisted in the armed forces.

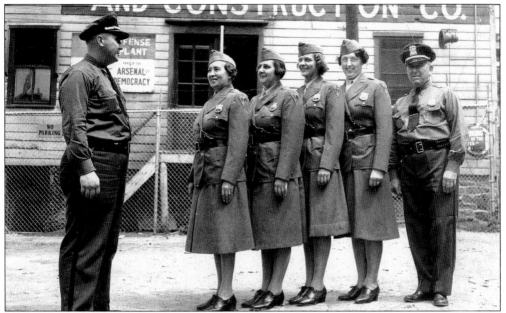

"Don't Sit under the Apple Tree." During World War II, the Greenport Basin and Construction Company began to produce ships for the government. The company's security staff included female volunteers (in uniforms reminiscent of the singing Andrews Sisters) and male police officers of the Coast Guard Reserve. From left to right are Theodore "Whitey" Howard, ? Lellman, Millie Chapman, Janet Sorenson Straussner, Martha McKinnon, and Ernest "Dutch" McComber.

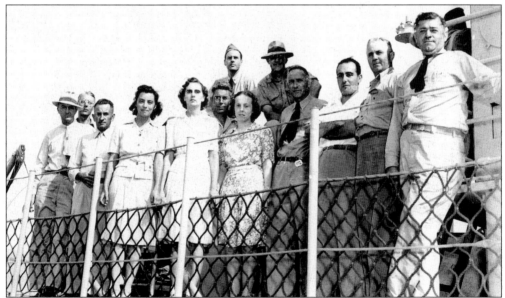

August 19, 1944. Pictured on minesweeper YMS-456, built by the Greenport Basin and Construction Company are, from left to right, ? Turton, ? Payne, ? Hawkins, Edna Ryder Ashworth, Miriam Hartley, Chester Ketcham, Lt. Cmdr. Nelson Chapman, H. Bush, Agnes Latham Geehreng, Ernest Wilsberg, P. Jannuzzim, W. Richmond, and O. Gedney. (Sherwood Rouse photograph.)

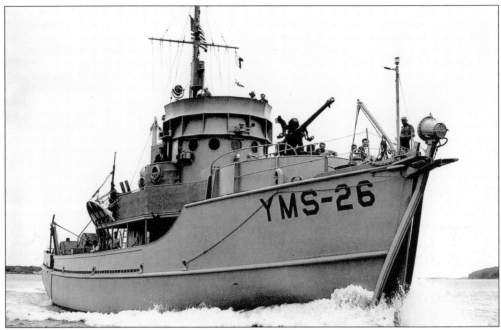

THE WAR EFFORT. Greenport employed hundreds of defense workers during World War II, attracting men and women from all over Long Island. Each shipyard was busy: two shifts a day on weekdays and work on Saturdays and Sundays as well. One of the key items produced was the YMS, the 135-foot minesweeper, built without metal in its hull so that it would not attract magnetic mines.

A FINE HARBOR ON THE ATLANTIC COAST. This ideally situated seaport was for many years a center for shipbuilding. In 1930, Greenport had five busy shipyards, with marine railways, sheds, and space for storing hundreds of boats.

Three

THEY MADE IT WORK

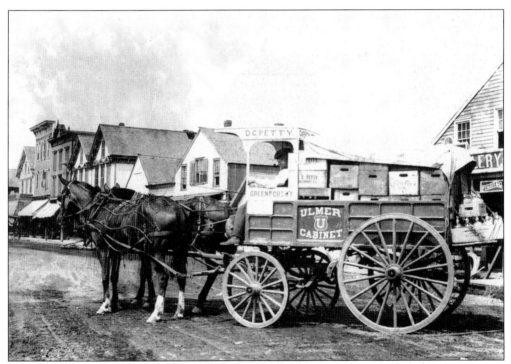

ALWAYS IN DEMAND. David C. Petty's deliveryman goes about his daily rounds in the early 20th century. Petty owned a saloon on Main Street and managed the icehouse. The staples of Greenport were the same as they are now: soda and beer, with sarsaparilla and root beer the favorites. Some of the other lower Main Street businesses, such as Preston's, are still flourishing.

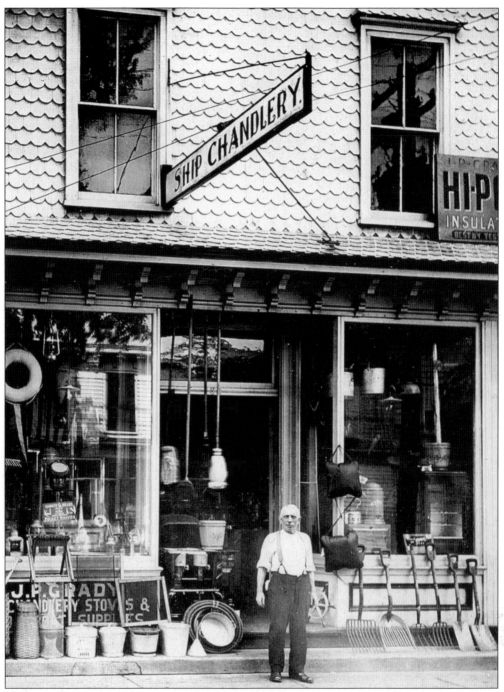

A Supplier of Marine Needs. James P. Grady, father of Margaret Grady Ireland, stands in front of his ship chandlery, at 208 Main Street. Grady later moved his shop to Front Street (later Burton's Bookstore). Famed bootlegger Legs Diamond is said to have run through the store with Grady's dog in hot pursuit as he fled from the feds. Before opening his own business, Grady was a foreman at the Sage Brickworks, which depended on immigrant labor to dig out the claypits. In 1902, the Sage Brickworks could produce 24 million bricks a year.

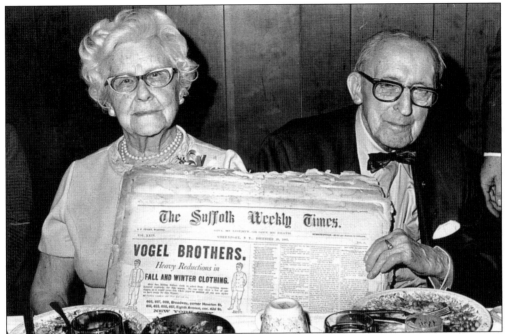

LOCAL NEWS. F. Langton Corwin was publisher of the *Suffolk Weekly Times*. He and his wife, Elsie Knapp Corwin, left a record of their work in the book *Greenport, Yesterday and Today, the Diary of a Country Newspaper*. Corwin's obituary, by Whitney Booth, appeared in the *Traveler-Watchman*. "Fred loved his native village in a manner impossible for a modern native. He grew to maturity while the 'home town' was the larger reality for all but the confirmed wanderer. . . . His long service to his village was truly a labor of love."

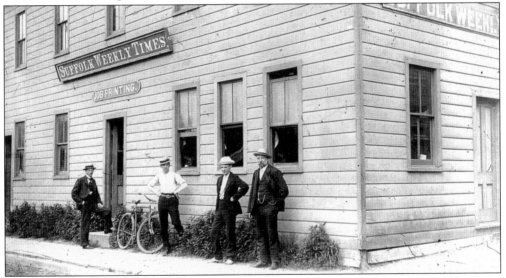

ESTABLISHED IN 1857. The second newspaper on the North Fork, the *Suffolk Weekly Times*, was started in Greenport by John Riddell. While Riddell served in the Civil War, the paper was run by Cordello E. Elmer. Buell David owned it in 1866, William Duvall in 1879, and Llewellyn Terry in 1875. Terry moved the paper from Front Street to South Street, which became known as Printing House Square.

AN EARLY GREENPORT PHYSICIAN. Dr. Treadwell Lewis Ireland graduated from the medical department of the University of the City of New York in 1846. He married Ella Wingate Page, one of Greenport's many early feminists. He practiced medicine in Southold hamlet for 12 years and then in Greenport village for nearly 40 years. His father, John Oakley Ireland, was Southold town supervisor during the Civil War.

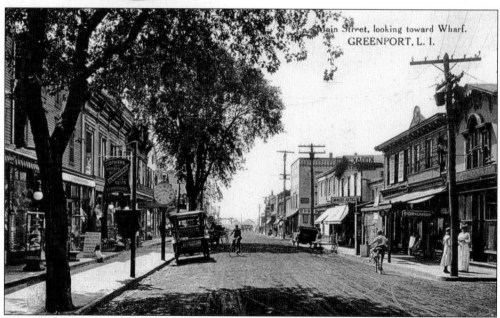

THE DOCK AT LONG WHARF. This dock was also known as Steamboat Wharf. Regular steamboat service was provided between New York, Sag Harbor, Greenport, and Shelter Island. Later, the iron steamers *Shelter Island*, *Montauk*, and *Shinnecock* connected Greenport with New York, Newport, New London, and Block Island. On the left are D.D. Webb's store and D.D. Wells's storehouse. On the right are Claudio's restaurant and Preston's coal office.

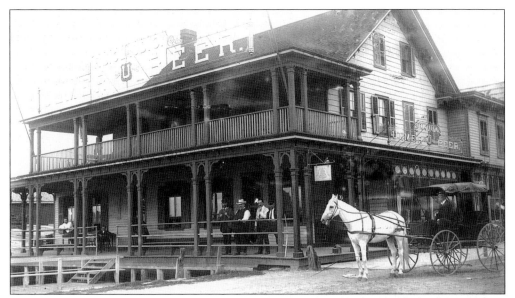

A WATERFRONT LANDMARK. In the mid-19th century, Manuel Claudio boarded a whaling ship and left his hometown of Fayal in the Azores. He decided to remain in Greenport, married a woman born in Ireland, and became a liquor dealer and restaurant owner. The business he founded has endured over time, a landmark on the village waterfront. A sign out front says that Claudio's is the oldest family-owned restaurant in the United States.

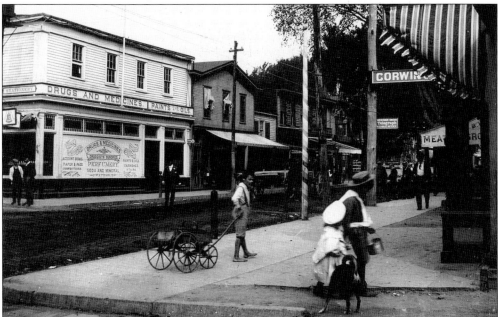

A STREETSCAPE. In the foreground of the familiar intersection of Front and Main Streets is the little street known as East Front Street, leading to the shipbuilding area. The store across the street, Kahn's Deli, was torn down *c.* 1950 and replaced by the Coronet Restaurant. The Corwin's sign (right) refers to a drugstore that was also the central office of the first telephone company, founded in 1895. The same building has held Kramer's Drug Store, the Cheese Emporium, and Bruce Bollman's Café.

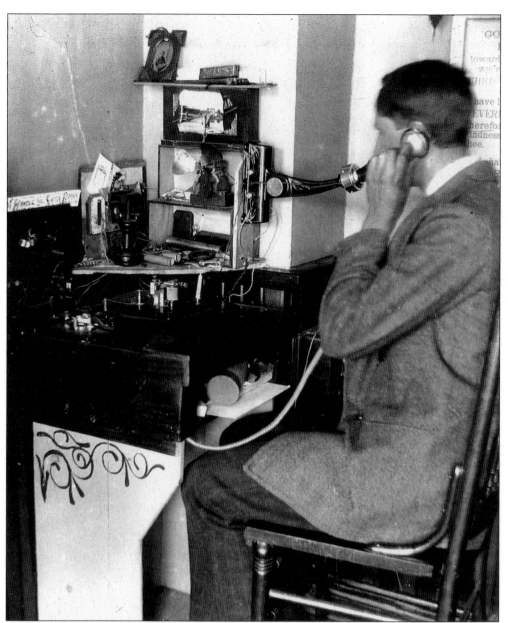

"HELLO, FRANK HARTLEY HERE." Frank Hartley was an accomplished inventor, electrician, photographer, and cartoonist who lived on First Street until he died in 1943 at the age of 61. He was also manager of Greenport's first telephone company, which was housed in Corwin's drugstore on Main Street. In addition, he was the first projectionist of films at the Opera House and was an expert on the silent film era. He is shown talking from home to a friend. Greenport Central had an office in the southwest front show window of the drugstore and operated from 8:00 a.m. to 8:00 p.m. with an hour break for lunch and another hour for supper. A larger switchboard was installed in the rear of the store, and after that a special building was built between Corwin's and the Reeve building for the "Hello Girls," as the operators were called. A man worked the night shift and served as janitor. He was given a folding bed and a loud night bell that would wake him to answer calls.

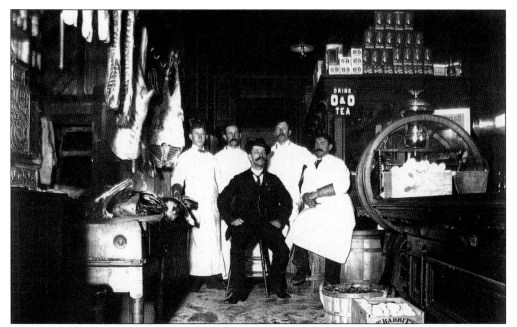

THE BUTCHER SHOP. Strickland's Meat Markets, which later became Wiggins' Store, combined the markets of Fred E. Strickland and William A. Loesser. It stood at the corner of Central and Main Streets where former mayor George Hubbard operated a Shell gas station for many years. The Strickland and Loesser shop, with sawdust on its floor, was deservedly busy until supermarkets arrived.

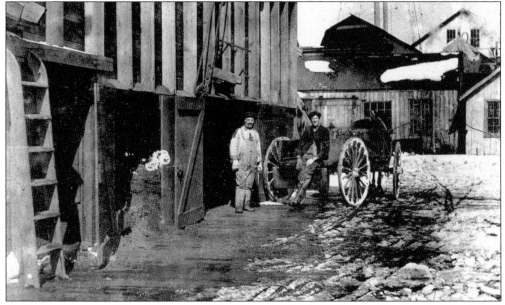

AN INNOVATION IN COAL DELIVERY. This photograph shows the coal shed at the Smith and Terry Shipyard, which later became the Greenport Basin and Construction Company. The coal was delivered by means of an aerial tramway directly from coal barges tied to the dock. The building with two windows (far right) is the Hedges building, which became one of Preston's gift shops.

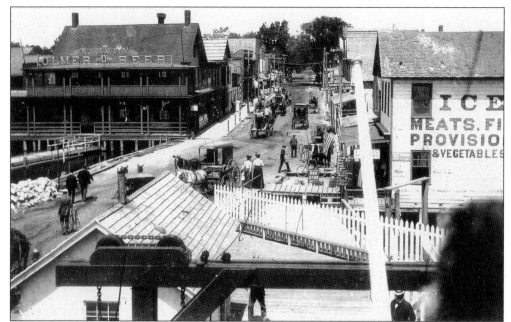

An Exciting Place to Be. At the right are D.D. Webb's store and D.D. Wells's storehouse. On the left are Claudio's and Preston's. Nearby are a sail loft, Berrian and Smith's shipyard, and two marine railways. Regular steamship service was provided between New York, Sag Harbor, Greenport, and Shelter Island.

Preston's Store and Dock. The president of Greenport village, Isaac Reeves, sits in his wagon in front of Preston's. The title of president was an early one, later replaced by mayor. The original wharf near Preston's was built in 1827. By 1857, there were three shipyards, four wharves, and many fish factories for the manufacture of bunker oil.

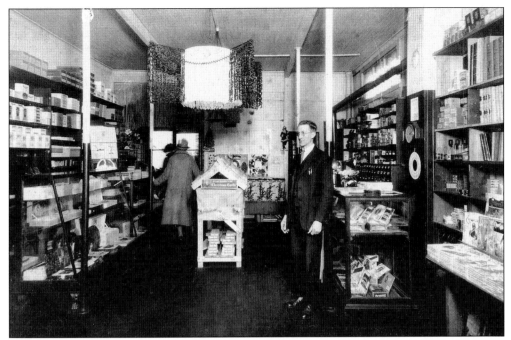

PRIDE OF OWNERSHIP. Reinhold Tappert opened this impressive shop, at 24 Front Street, in 1923. In addition to books, he sold cigars, cards, newspapers, and office supplies. The store was at the same address as the former Drach's Cigar Store, run by Tappert's grandparents, who purchased the property from Nathan Kaplan in 1879. Tappert's closed in 1971.

ALMOST INSTANT MESSAGING. Tappert's store was Greenport's Western Union headquarters. Through the magic of the telegram, Rachel Olstad Valentine was able to let her husband, Howard Valentine, in the village know that she had arrived safely in Buffalo. She owned and operated the George H. Corwin insurance agency from 1943 to 1992.

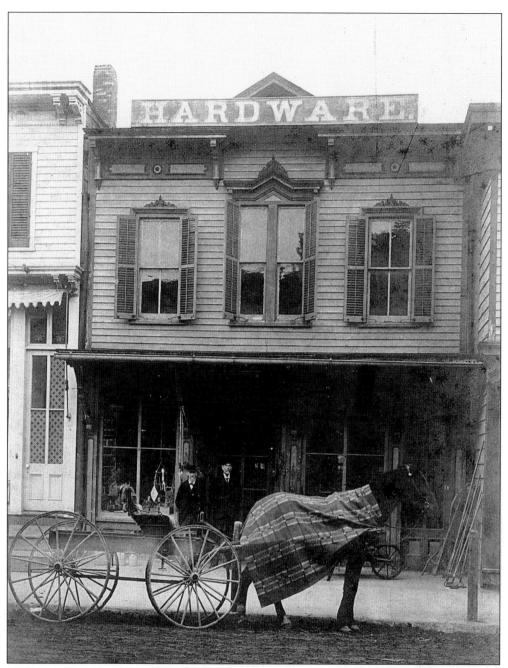

A VENERABLE CITIZEN. This photograph shows the J.G. Champlin Hardware Store in February 1903. John G. Champlin was a grocer in a store at Front and Main Streets, according to the *1868–1869 Directory by Curtin*. A street just outside the incorporated village bears the Champlin name, although the family is not listed in the *1910–1911 Southold-Shelter Island Register*. At the time this photograph was taken, the roads were of dirt and extremely dusty (many Greenport streets were not surfaced until *c.* 1910). First the bicycle craze and then the arrival of the automobile created the demand that eventually led to cement sidewalks and macadam roads.

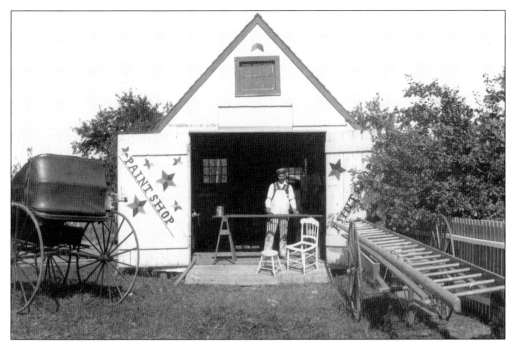

AN INDIVIDUALISTIC SHED. Fredwin H. Thompson is shown in his paint shop *c.* 1915, an artisan at work. Because of the small size of the incorporated village, advantage had to be taken of every square foot of property. People often ran their businesses out of their homes, except for those professional businesspeople who had offices on Lower Main Street. Many lawyers and architects from Riverhead had branch offices in Greenport Village.

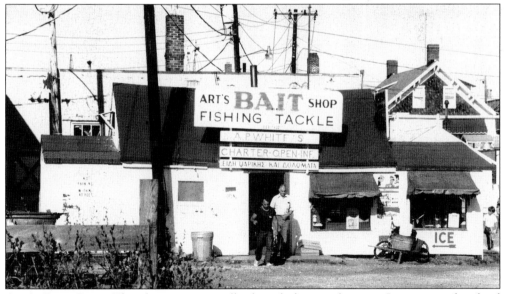

ART'S BAIT SHOP. This shop was originally the pilothouse of a scow. It was moved to land owned by Harry Katz, becoming a shack for opening scallops. Many similar structures dotted the Greenport landscape when shellfishing was at its peak. Arthur White bought the building in 1932, and after World War II, his son, Arthur P. White, went into the bait business, prospering in a town that loved fishing. The business was sold in 2003 to Ken Birmingham.

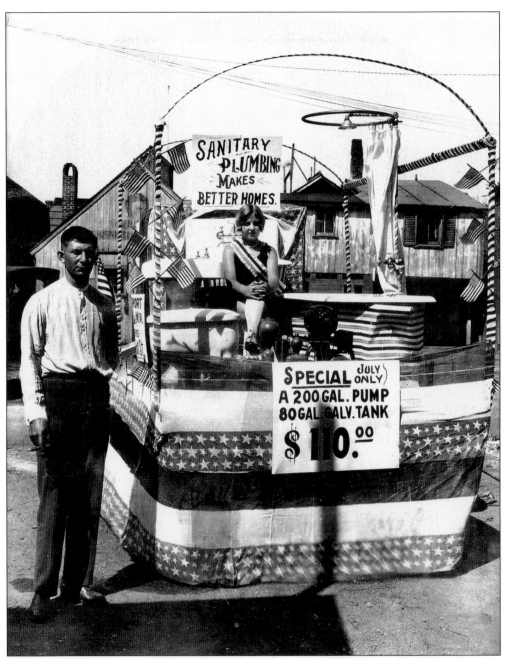

THE LUXURY OF BATHING. Sanitary sewers were finished and connected in Greenport in June 1894. Although the Greenport Water Company was begun in 1887, it was not until 1930 that 95 percent of the village received a public water supply. That left some homes without indoor plumbing. There was a time when one could rent a space on Main Street to take a bath or shower. A float advertising sanitary plumbing prepares to take its place in a parade *c.* 1920. There were at least half a dozen plumbers in the village, as well as painters, decorators, and hardware stores that could benefit when sanitary plumbing was installed.

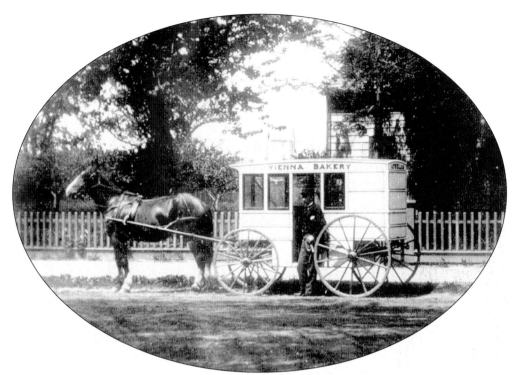

A WELL-DRESSED DELIVERY MAN. L.T. Wells and his Vienna Bakery wagon made stops between Greenport and Orient. The village was the commercial center of Southold town and, even as early as 1868, contained shoemakers, milliners, potters, confectioners, and cabinetmakers. It was an adventure to travel to the village to shop. Most people preferred having tradesmen come to them.

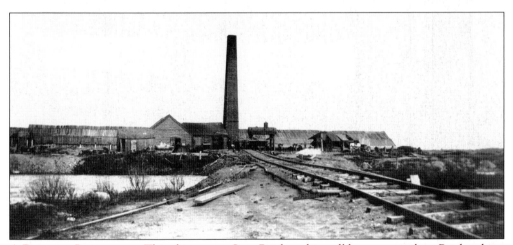

A BOATING LANDMARK. This chimney at Sage Brickyard is well known to sailors. Brickmaking was one of the earliest industries in Southold town. An extra fine quality of brick clay was discovered at Arshamomaque and furnished bricks for the settlers before 1657. Until the hurricane of 1938 destroyed the clay beds, the brickyards provided jobs for Irish, Scottish, and Italian immigrants.

AN IMMIGRANT COUPLE. Toward the end of the 19th century, new names and faces began to appear in Greenport. Many were from Italy, such as the couple in this photograph. Pietro Cafarelli and his wife, Lucia Bucci, were married in Popoli, Italy, in 1871. They emigrated to the United States in 1890. They were drawn to Greenport because work was available nearby at Sage's Brickyard.

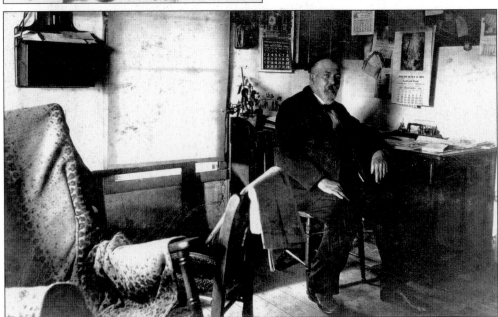

THE PRESIDENT OF THE BRICK COMPANY. De Witt Clinton Sage established the Sage Brickyard in greater Greenport in 1887. The business soon employed over 200 men, mostly immigrants. The depression of the 1930s and the hurricane of 1938 both had a hand in bringing to an end the brickmaking business on the East End of Long Island.

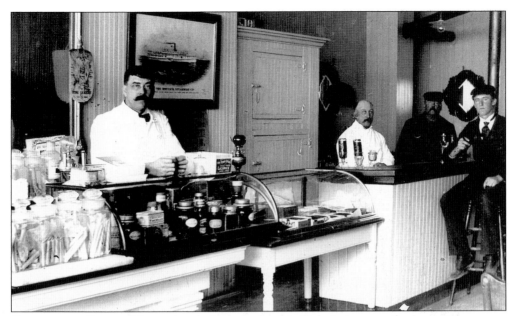

CIGARS AND CANDY. Men enjoy their stogies in this 19th-century confectionary-cigar store, where the soda fountain (right) served seltzer and root beer. Children loved coming here to sample the delicious hard candy sticks, like those in *Little Women*. The shop was one of the many mom-and-pop stores that once peppered Greenport.

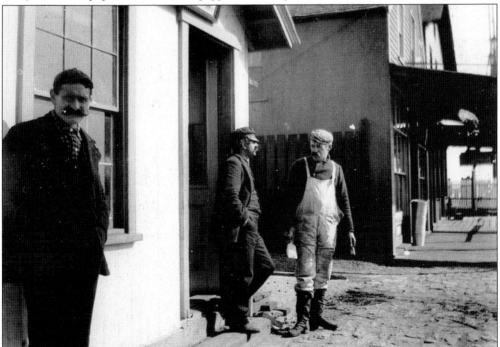

THE FUEL SUPPLY FOR THE 1890S. Wells Coal and Gas was on lower Main Street next to Preston's Ship Chandlery and Grocery. In 1909, Wells Coal and Gas was called Wells and Jennings: Lumber, Coal and Wood, with lumber sheds nearby. An indication of the age of this photograph is that stone sidewalks were replaced by cement ones in 1894.

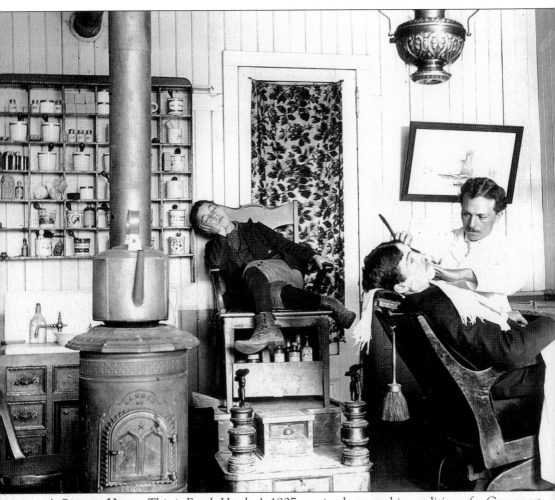

A STEADY HAND. This is Frank Hartley's 1907 comic photographic rendition of a Greenport barbershop run by Sam Mazzo, pictured above in Sweeney Todd fashion. This appears to be the same tonsorial parlor on Main Street that Tony Ficurilli runs today as Anton's Salon. Photographing local people and businesses was only one string in Hartley's bow. His creativity is described elsewhere in this book. His father, Charles W. Hartley, was a harness maker, according to *Curtin's 1868-1869 Greenport Directory*. Hartley probably could have been famous had he chosen a larger stage. Instead, he was born in the village, and he lived and died here. The Southold Historical Society has reprinted many of Hartley's glass-plate negatives.

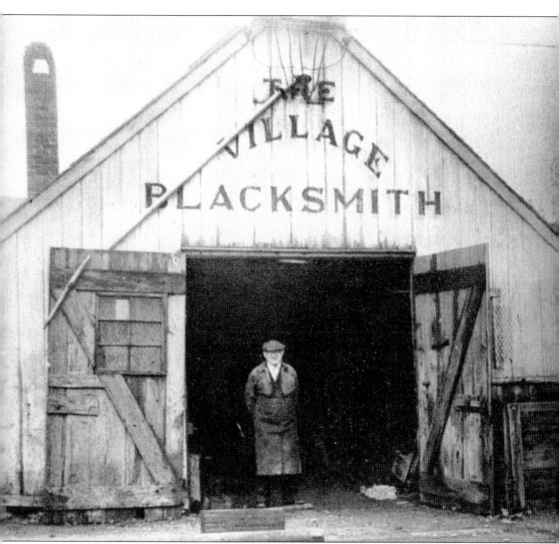

THE VILLAGE SMITHY, C. 1930. Charlie Myers was Paul Nossilik's uncle and his predecessor as village blacksmith. Paul Nossilik was in the Austrian army during World War I and later witnessed the regrowth of German military might. He came to the United States and found work at a hotel on Shelter Island during the 1930s. Eventually, he replaced his uncle as blacksmith in Greenport. Nossilik's dedication to his work was such that he allegedly remained inside the blacksmith shop all through the hurricane of 1938. Blacksmithing has always been one of the most important trades on the North Fork of Long Island from Colonial times until the appearance of the horseless carriage.

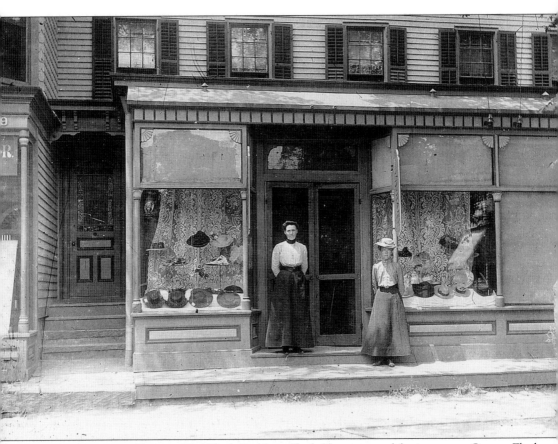

THE TALENTED FLACKS. The Flack Building (far left) was named for its owner, George Flack, a painter who sold art materials. Flack had two gifted daughters, author Marjorie Flack, first married to artist Karl Larsson and then to poet William Rose Benét, and Edith Flack, married to lithographer Stow Wengenroth. Wengenroth was described by Andrew Wyeth as "the greatest black-and-white artist in America." Edith Flack was an authority on marionettes and wrote about them. She and her husband lived in Greenport. Marjorie Flack attended the Art Students League and was a fellow of the MacDowell Colony. Her book *The Boats on the River* was the runner-up for the Caldecott Medal in 1947. A movie based on another of her books, *The Story About Ping,* was shown at the Venice International Film Festival in 1956. The building was originally known as the Timson Hotel. Once owned by E.J. Warner, it was later owned by Ken and Loretta Dimon and their children.

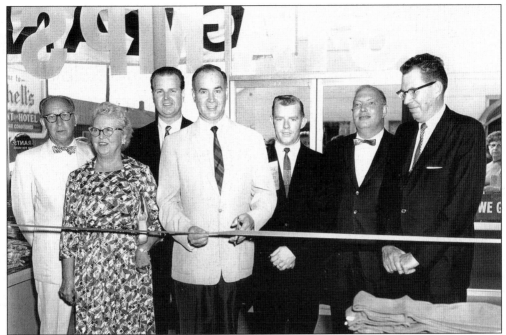

A STORE OPENING. Mayor Ralph Quinton does the honors at the opening of a large new Grant's store, across Front Street from Mitchell's Restaurant. To the left of Mayor Quinton are Tammy and Mabel Barth. Grant's was built on the site of the well-known and well-nigh historic Barth's Saloon.

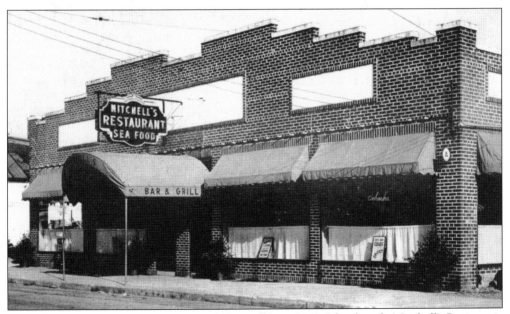

A SUNDAY DRIVE DESTINATION. People from all over Long Island made Mitchell's Restaurant their day-off destination. From 1933 to 1978, this was the North Fork's place to be seen. The lounge had a Tiffany glass canopy, and the walls were covered with enlargements of local photographs. Greenport's Rotary Club met in a separate dining room.

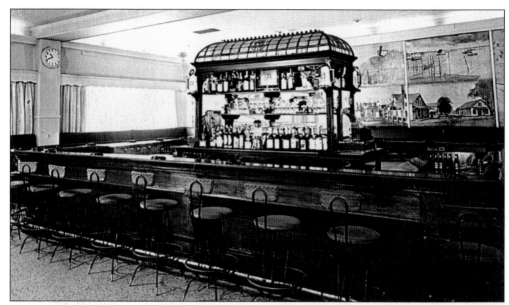

THE BAROQUE BAR. Greenport people went to Mitchell's Restaurant from the 1940s to 1978, when fire destroyed the establishment. Originally, the canopy bar was the centerpiece of Ed Ging's Saloon, on Main Street. During its second incarnation as part of the Mitchell empire, it featured as fine a medley of imbibers and talkers as could be found anywhere. British essayist Alistair Cooke could often be seen on Friday nights occupying the barstool at the lower right.

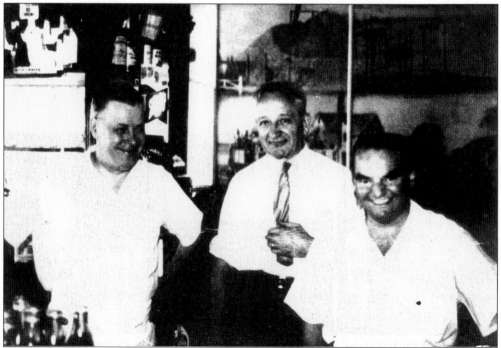

HIGH SPIRITS. Posing here are three of the best-known bartenders in town: John Cowan (left), Harry Mitchell (center), and "Scotty" Campbell. (Courtesy of John Cowan's daughter Helen Cowan Grigonis.)

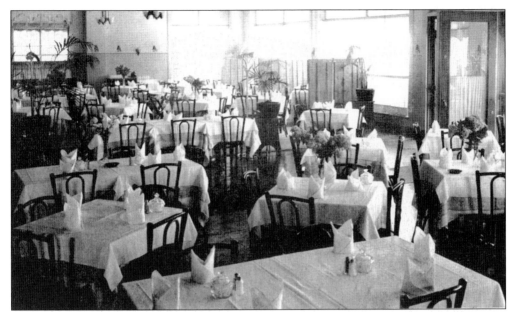

MITCHELL'S DINING ROOM. The dining room was the domain of Pauline Mitchell, who ran the dining room like a general commanding her troops. Her weapons were crisp aprons, crisp linens, cheerful and attentive waitpersons, and lots of good food at reasonable prices. The wife of Harry Mitchell, she had a high energy level that was always at the forefront, whether she was serving local people or celebrities like Alfred Drake, Vincent Sardi, and playwright Jason Miller.

AN ENTREPRENEUR. Keeping pace with the popularity of boating and fishing, Harry Mitchell bought the land in back of his restaurant, the former Wood and Chute Shipyard and Cedar Island Oyster Company, in 1947. The prime waterfront property was developed by Mitchell into one of the finest boat landings on the East Coast.

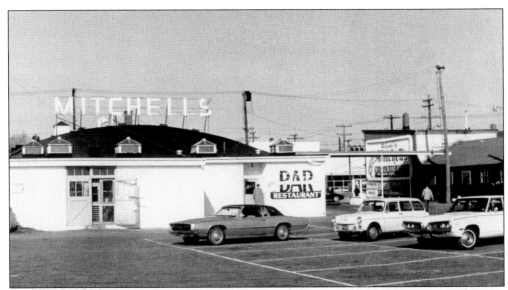

A Rear View of Mitchell's. The back of Mitchell's was more familiar to most than was the front of the building. Mitchell's opened in 1933 in a former garage and service station on Front Street. Harry Mitchell and Edward Seeley built a dance floor and provided an orchestra three nights a week. Mitchell had been in charge of the meat department in the H.C. Bohack store, on lower Main Street. Seely is said to have had considerable prior experience in the restaurant business.

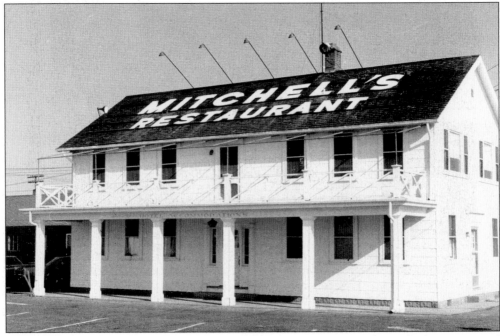

Successful at Business. The land on which this 16-unit motel was built was one of seven separate purchases that made Harry Mitchell owner of almost one-third of downtown Greenport's waterfront. The enterprise included a marina, with space for 130 boats, and the largest restaurant on the North Fork.

GOOD COOKING. In his 1982 obituary, Arnold Mitchell was described as a "well-known chef and restaurateur"—and that was no lie. Mitchell began his career cooking at the popular (and, later, landmark) Mitchell's Restaurant in Greenport. Soon after the Japanese attack on Pearl Harbor, on December 7, 1941, Mitchell entered the U.S. Coast Guard. He served for three years—part of the time in the Greenport Coastal Picket Patrol on the local yacht *Sea Gypsy*. Later, he and his wife, Mary Vail Mitchell, operated the Orient Point Inn. He was also a chef at the Hotel Henry Perkins in Riverhead, the Patchogue Hotel, Felice's of Patchogue, and the Seafarer in Southold.

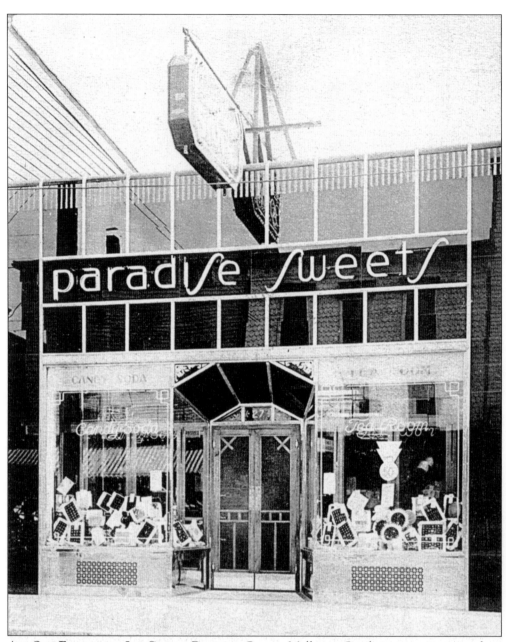

An Old-Fashioned Ice-Cream Parlor. George Mellas, a Greek immigrant, opened an ice-cream parlor in 1923, but it was destroyed by fire in 1933. Mellas, acclaimed as one of Greenport's best-known and progressive businessmen, replaced the ruins with a modern fireproof store. An expert in the ice-cream business, he had interests in ice-cream parlors in Southold and Mattituck, as well as this fine one, at 27 Front Street. He was 36 years of age when he died in a tragic automobile accident at Mill Creek, leaving a wife and eight children. For a short time, his widow and her brother, Harold de Ronde, operated the shop, which in its day was one of the most up-to-date stores in the village. Later, it was sold to Peter Pappas, proprietor of the Sag Harbor Candy Kitchen. Later still, it became a popular restaurant, the Frisky Oyster.

Four

COMMUNITY

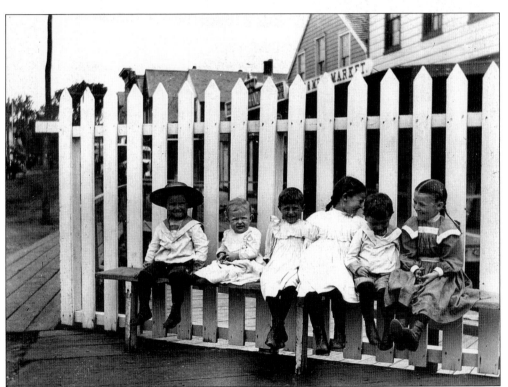

A IS FOR ADORABLE. A group of children waits on lower Main Street for the ferry to Shelter Island. The S.T. Preston ship chandlery (background) was originally known as S.T. Preston and Son. It was founded as a ship chandlery and grocery in 1883, a busy time for Greenport's shipyards and docks. Later, under the leadership of the Fagan and Rowsom families, Preston's grew into a world-famous mail-order business.

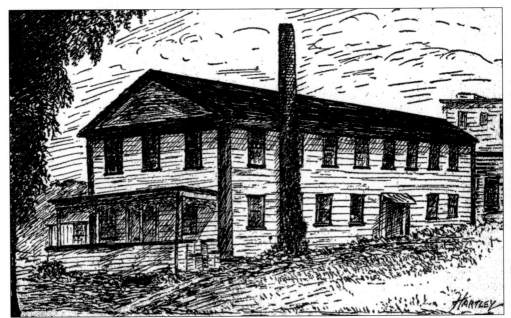

GREENPORT'S ORIGINAL SCHOOL. This sketch by Frank Hartley depicts the school building that was constructed on First Street in 1842. Later, the school moved to Third Street, where a primary school was built of brick in 1910 and a wooden middle school was added later.

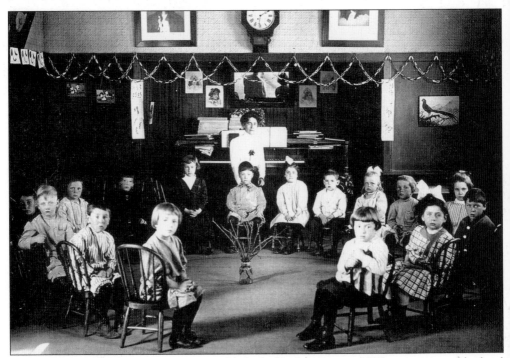

A KINDERGARTEN CLASS. Greenport established a kindergarten in 1897, moving an old school on the North Road down near the Third Street firehouse. During that same year, Greenport registered an academic high school with New York State. In 1905, a separate high school building was completed.

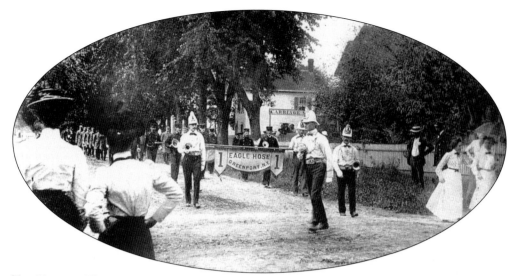

THE EAGLES. This company was organized on February 10, 1871. Three of its members deserve special commendation: Chief G. Archer Rackett, for motorizing the fire department in 1920; Mayor Ansel V. Young, for helping to establish the municipal sewer system through the Works Progress Administration in the 1930s; and Harry Monsell, for serving as superintendent of public works for over 50 years.

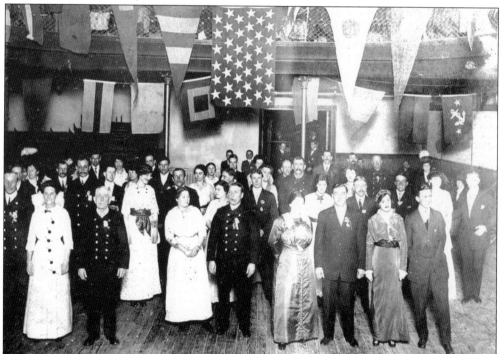

A YEARLY EVENT. Every February, Greenport's fire companies celebrated Washington's Birthday with a parade; a scallop, eel, and clam chowder supper; and a grand ball at the Greenport Auditorium. During the 1920s and 1930s, John Sherwood led the grand march. Among those pictured are the Gradys, the Rogers, the Adams, the Griffings, the Earl Lintons, the Edward Conklins, Theodore "Whitey" Howard Sr., George Capon, Mamie Hassett, and Mr. Sherwood.

AID TO THE ROUGH RIDERS. In 1898, Ella Wingate Ireland, the wife of a local doctor, chartered a steamer and, with 45 men and women from Greenport, Southold, East Marion, and Orient, carried fresh produce, baked goods, dairy products, and hand-knitted socks to the injured troops of Col. Theodore Roosevelt's 1st U.S. Volunteer Cavalry at Montauk. The trip was reported in the *Brooklyn Daily Eagle*.

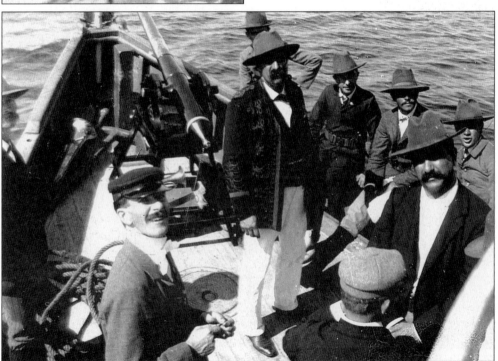

A DAY ON PECONIC BAY. The sporty men in this bunch wear gun belts and carry musical instruments. The mustaches indicate that they might be going to a reunion of Roosevelt's Rough Riders at Montauk. They could also be army musicians ready to perform at one of the many government forts at the end of the island.

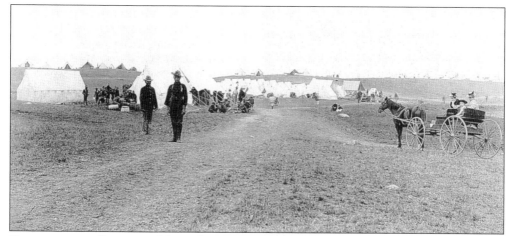

QUARANTINED SOLDIERS. Upon their return from the Spanish-American War in 1898, Col. Theodore Roosevelt and his troops, many suffering from contagious diseases, were sent to Camp Wyckoff, in Montauk. Horton's Funeral Home in Greenport, under contract with the federal government, picked up dead soldiers at the camp. Typhoid, malaria, and dysentery were the main causes of over 300 deaths that occurred there.

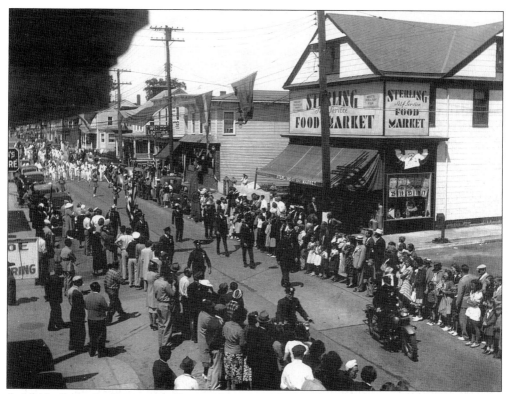

A 1940s PARADE, FIRST AND FRONT STREETS. The Sterling Market was operated by Oscar Goldin, who served one term as mayor of Greenport. The market later became the site of Colonial Drugs. A sign for Sportsmen's Cigar Store is barely visible on the left. The proprietor of the cigar store was Albert Martocchia, who was appointed Southold town supervisor in 1969 and then subsequently elected to the office. Martocchia served until his death in 1979.

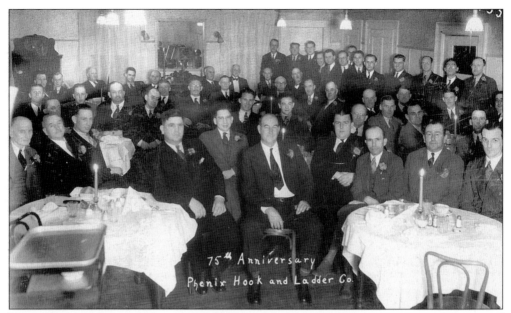

THREE-QUARTERS OF A CENTURY OF SERVICE. Shown is the 75th-anniversary celebration of the Phenix Hook and Ladder Company (formed in 1860), at the Hotel Wyandank in 1935. Among those identified are Joseph "Hooker" Smith; Ansel Young; Effingham Townsend, assistant chief of the company; Frank "Sparky" Coyle; Serafina Brandi; Harry Shipman; Fred Booth; Harry Thornhill; Emmons Dean; William Biggs; and Sam Levine.

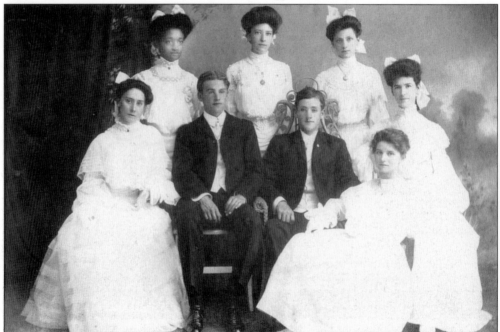

GRACEFUL AND REFINED. This group of young people is the 1904 graduating class from Greenport High School. The two young men, Schuyler W. Horton and Stanley Duvall, were later roommates at Syracuse University, and the young woman in the back left is Mabel Hopkins, the first black graduate of Greenport High School.

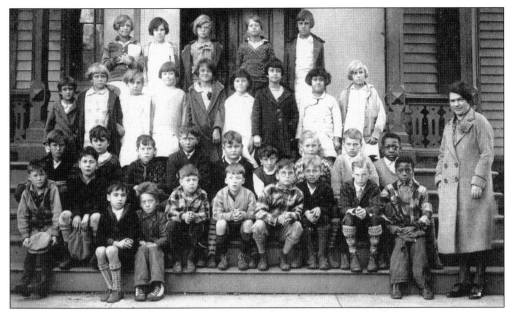

THE 1927 THIRD-GRADE CLASS. The class teacher, Miss Snyder (right), wears an overcoat, sensible shoes, and a slouch hat. The schoolchildren are, from left to right, as follows: (first row) Woodrow Angell, Allan Wells, Wes Rowland, Walter Chute, Frank Claudio, Arcole Schiavoni, Harry Klefve, Ludwig Fiedler, Leon Sells, and Joe Escallette; (second row) Francis De Lalla, Lewis Foster, "Dutch" McComber, Walter Lindsay, Jack Sherwood, Bob Cooper, unidentified, Donald Clark, and Moses Walker; (third row) Fannie Golisz, Virginia Capon, Bernice Malinauskas, Kay Rogers, unidentified, Julia Dawson, Evelyn Hudson, Marie Schiavoni, and Veronica Malinauskas; (fourth row) "Toots" Rogers, unidentified, Norma Hammond, Janet Reeves, and Bonnie Binkis.

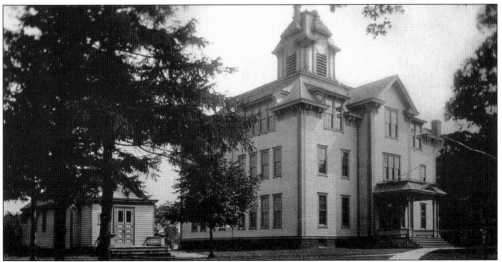

THE IMPORTANCE OF EDUCATION. From its founding in 1640, the town of Southold emphasized the importance of education. Surely even before Greenport built its kindergarten in 1897, children were schooled at home, either by their parents or by itinerant teachers who were paid to hold classes in private homes. The old kindergarten (left) was moved from the North Road, and the 1880 grammar school (right) was designed by architect George Skidmore.

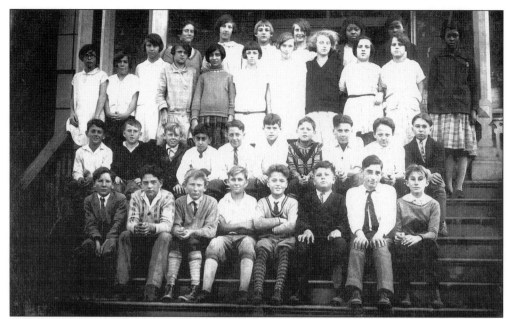

HEADING FOR A 1929 GRADUATION. These schoolchildren are, from left to right, as follows: (first row) Walter Hulse, Louis Brandi, John Dewaal, Ignatius Stankowicz, Arlington "Reginald" Muller, George "Walter" Sledjeski, Peter Miranda, and William Hunton; (second row) Jay Deale, William Quinn, Leo Tillinghast, Siab Slefstein, Edward Corwin, Benjamin Adams, Irving Sachs, Carleton Chute, William Berliner, and Howard Valentine; (third row) Marie Riley, Margery Conklin, Jessie White, Catherine Hayes, Katherine Schiavoni, Anna Hulse, Edna Jones, Merle Pemberton, Gertrude White, Bernice Mills, and Annette Hayes; (fourth row) Jennie Richards, Alice Moore, Josephine Salter, Wilhemina Katzenmayer, Bertha Smith, and Winifred Howard.

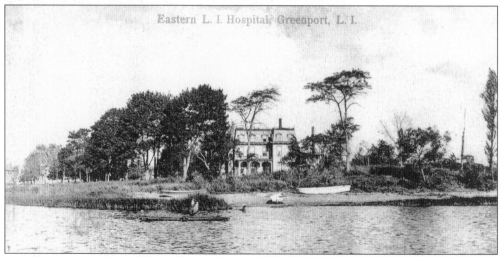

THE MANSION ON THE CREEK. In 1856, local builder Orange Cleaves was contracted by New Yorker Isaac Holbrook to build this dwelling on Stirling Creek. Holbrook was a lavish entertainer and used the house often, but in 1890 he sold it for $2,700 to Abraham Sully, manager of the Greenport House. The handsome home changed hands several more times, eventually becoming Eastern Long Island Hospital.

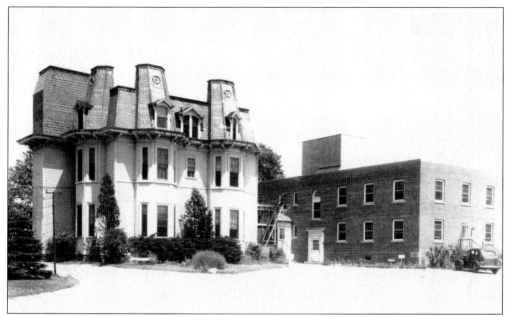

YESTERDAY AND TODAY. Shown are the first Eastern Long Island Hospital building and the beginning of a modern hospital. The first addition was built in 1932. Containing a children's ward and a delivery room, it cost about $10,000. An entire new wing was added at a cost of about $85,000 in 1939, increasing the capacity to 40 beds.

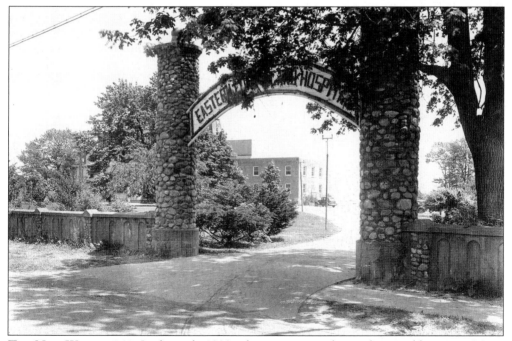

THE NEW WING, 1949. In the early 1900s, the mansion on the creek was sold to sisters Maria and Mary Evalina Wood of Greenport, who offered the building, rent free, for a hospital. The first meeting of the hospital association took place in 1905. The fully equipped (for its time) hospital opened on June 24, 1907.

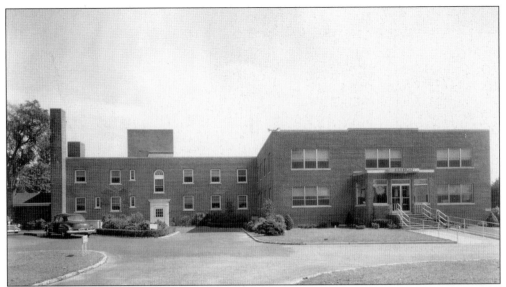

THE HOSPITAL. The cornerstone of the present Eastern Long Island Hospital (ELIH) was laid in 1949. It was "the only hospital east of Mineola," according to Elsie Knapp Corwin. The auxiliary made possible the opening of a heliport in 1977 and an expanded emergency room and outpatient unit in 1979. Today, the hospital continues to expand and improve.

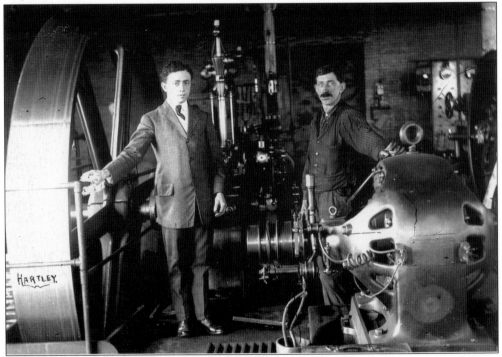

THE EARLY LIGHT PLANT, c. 1903. The Greenport Electric Light Plant was located on South Street, across from the IGA parking lot. In 1903, a new brick engine room was installed at the water plant on Moore's Lane to establish a lighting plant there. All additions and improvements that have been made over the years to the electrical department have been paid from the earnings of the plant.

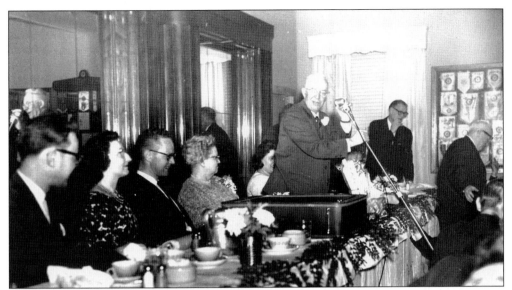

A True Public Servant. A retirement dinner is held for Harry Monroe Monsell (standing, center) and his family at Mitchell's Restaurant in 1964. Monsell was appointed temporary superintendent of public works in 1920, after the accidental death of Superintendent Redman. After a course of study, Monsell's position was made permanent in 1924. He served the village of Greenport for 50 years.

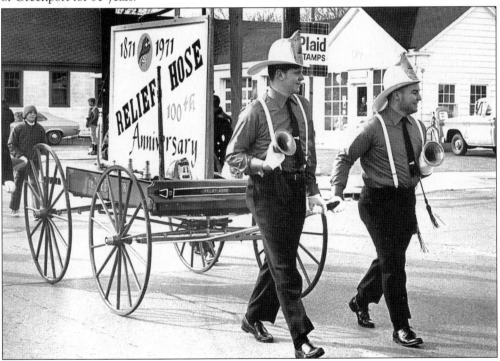

The Washington's Birthday Parade, 1971. Greenport firemen Fred Rempe Jr. (left) and Ritchie Sycz pull a hose cart belonging to the Relief Hose Company, formed in April 1871. The 27-year-old Sycz perished with 18-year-old Edward Bruce Bellefountaine on June 11, 1977, "when they entered a smoke-filled house believing a child was trapped inside."

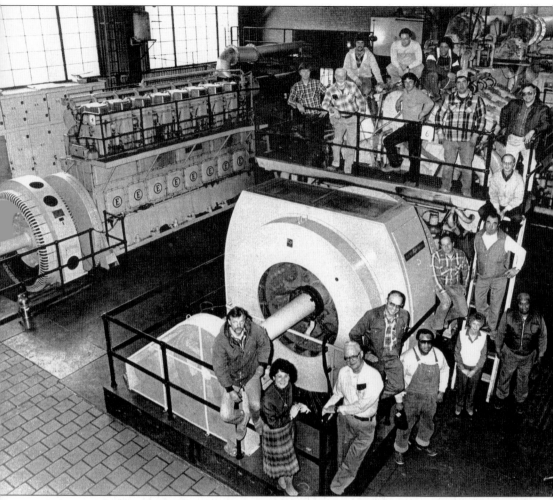

LIGHTING IT UP, 1994. Shown with its full production team, Greenport's Electric Light Plant, on Moore's Lane, was the only municipally owned electric light plant in Suffolk County—yet another distinction for the incorporated village. In February 1887, the Greenport Light and Power Company was formed by private investors to furnish light and power to the village. The first power plant was on South Street. In 1898, the Greenport Water Company, another stock company, was sold to the village, which also took over the lighting company in 1899. Almost $70,000 in taxpayer-approved funds was spent to purchase both companies. (Photograph by Judy Ahrens; courtesy the *Suffolk Times*.)

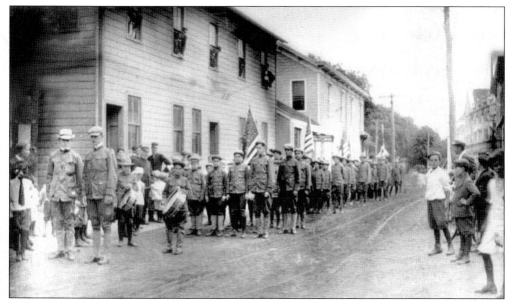

THE GREENPORT LIBRARY. In this early view taken on South Street, the sign at the left says, "Greenport Library." The first recorded lending library in the village was in Luther Moore's store, at the corner of Main Street and Bay Avenue, in 1845. The library was later moved across the street to what became the Opportunity Shop of Eastern Long Island Hospital. In 1877, the Greenport Literary Society was organized to promote literature and culture in the community.

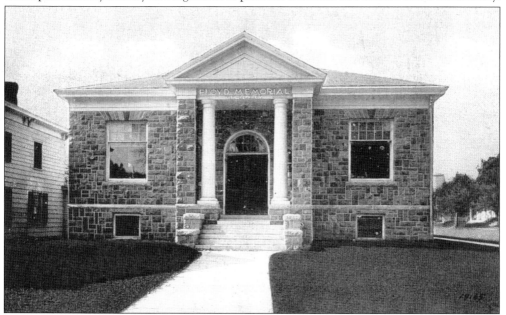

THE VILLAGE LIBRARY. Floyd Memorial Library opened in November 1917 at First and North Streets on the site of the burned-out Congregational church. The library was a gift from Grace Floyd in memory of her father, David Floyd, the grandson of William Floyd, a signer of the Declaration of Independence. The library was built of the same stone as Brecknock Hall, the Floyd home on the North Road. Elizabeth Deale was the first librarian. A new wing was dedicated on May 26, 1999.

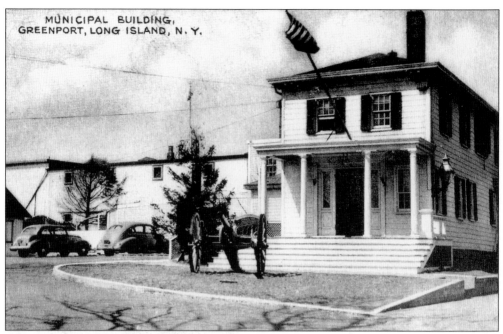

THE OLD HEADQUARTERS. The Greenport police station was once housed in the original kitchen of the historic Clark House, built in 1831. An outstanding example of Colonial architecture, the hostelry was torn down in 1935, after the village board purchased the property for a municipal parking lot. The police station contained public rest rooms, an attraction for shoppers from outside Greenport.

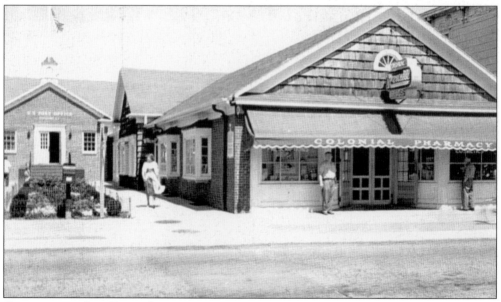

ONE OF THE OLD POST OFFICES. In 1954, young veterans Leo Schneider and Franklin Mountain bought the two-year-old Colonial Pharmacy from Archie Kaplan. Behind the drugstore to the right were Irma Hutter's gift shop and Valentine Insurance. West of the post office were Mazzo's barbershop and the office of Arthur Goldin, D.D.S.

AN IMPOSING FIGURE. Theodore B. Howard, Greenport's chief of police, is pictured here. The grandfather of Barbara Howard Fanning, he was first assigned by village trustees in 1911 to be stationed at the "very dangerous corner" of Main and Front Streets. His successor as chief was Joseph "Hooker" Smith.

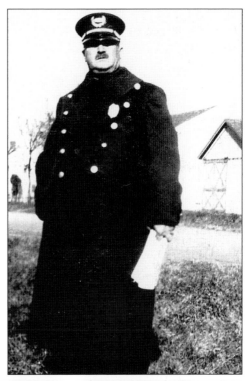

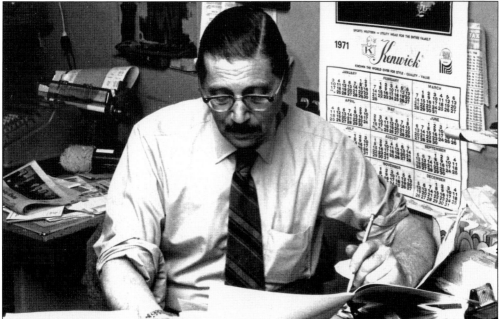

A MAYOR AND BUSINESSMAN, 1971. Arthur Levine served two terms as mayor of Greenport. He was the proprietor of the Arcade Department Store, which was founded in 1928 by his father, Samuel Levine, on Front Street. For many years, Samuel Levine and his brother Julius Levine had a grocery store in the Main Street shop that later became Clinton A. Hommel Plumbing and Heating. (Photograph by Whitney Booth.)

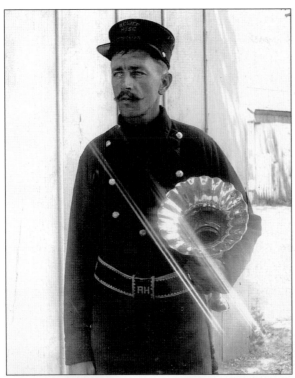

A FIREMAN WITH A HORN. In early-20th-century Greenport, many residents bore the name Conklin. This Mr. Conklin belonged to Relief Hose Company No. 2, which was organized in April 1871. After occupying several locations, the company moved into Fire Station No. 1 on January 31, 1969.

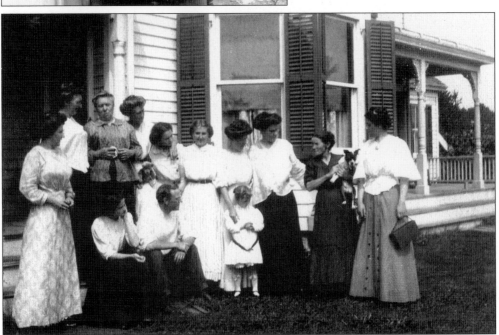

A TYPICAL FAMILY GROUP. The Straussner family stands in front of 1111 Main Street, across from a monument and granite business. The Straussners originally came from Germany and England. On the left is Annie Straussner, the wife of Antone A. Straussner. Their son Gus Straussner had the first gas station in the village in the 1930s, a Socony station on the North Road.

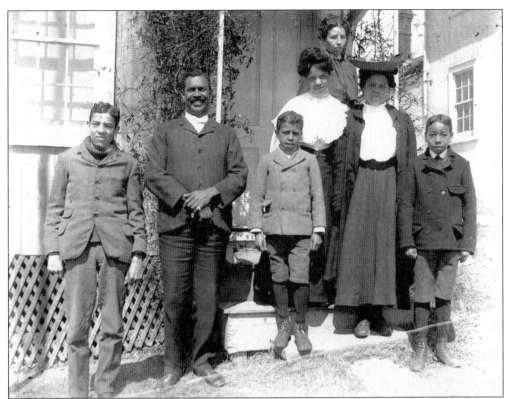

LOST TO HISTORY. This earnest and charming Greenport family is typical of the many hardworking people who were employed in the village in various branches of the fishing industry. Although the photograph was exhibited at the Masonic temple in 2001 in the hope that someone might be able to identify the people, no one has so far.

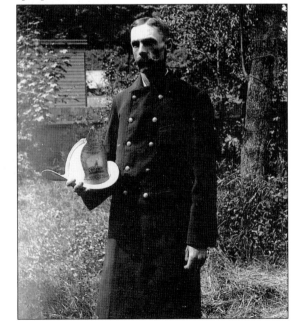

HARRY H. YOUNG. Harry Young was the fire chief of the Eagle Hose Company, which was established by former members of the Empire Engine Company No. 1 on February 10, 1871. His fire hat reads, "Chief Engineer Greenport, N.Y." He held the position from 1898 to 1900. Monroe Biggs was the first foreman of the fire company.

A SUCCESS STORY. Greenport-born in 1869, Herbert L. Fordham worked in the N.H. and T.D. Fordham sail loft (later, William Mills) for three years after graduating from Greenport High School. The arduous work convinced him to apply for a scholarship to Cornell University, which he won. Fordham began practicing law in 1921 and eventually acquired a 54-acre estate, Oak Lawn, on Long Island Sound. The estate became Fordham Acres in 1965, when it was divided into building lots.

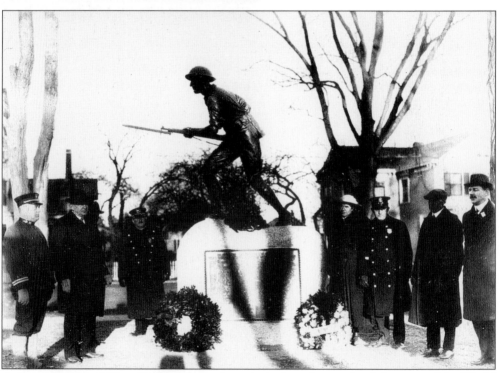

A CIVIC LEADER. Lillian Townsend was the principal speaker at the dedication of the World War I memorial. Veterans Memorial Park, familiarly known as Steamboat Corner, is at the fork of First and Main Streets. The childhood home of film historian Paul Jensen, which later became a part of Townsend Manor Inn, is at the right.

A GREENPORT FIRE CHIEF. Thomas Ralph Watkins was appointed to the fire department by the village board in January 1984. With well over 30 years of experience in the emergency medical field, he taught related subjects to various companies. Over the years, he served as second lieutenant, captain, assistant chief, and chief. In 2002, he was elected president of the Southold Town Fire Chief's Council.

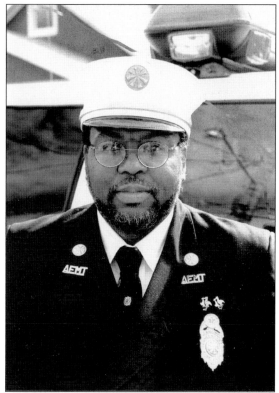

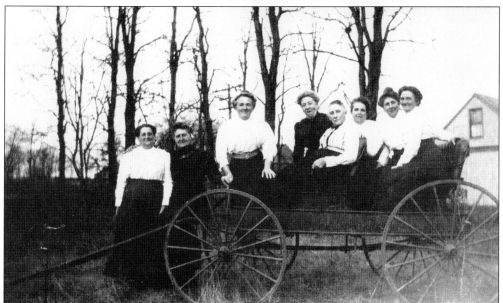

WOMEN AT WORK. Greenport women cooked, cleaned, put up food, and ran boardinghouses. They also worked as dressmakers, milliners, salesladies, and bookkeepers, according to a 1910 village census reported in the *Southold-Shelter Island Register*. They served as maids, teachers, stenographers, nurses, and matrons at Eastern Long Island Hospital. At the village's many hotels, they worked as managers and waitresses.

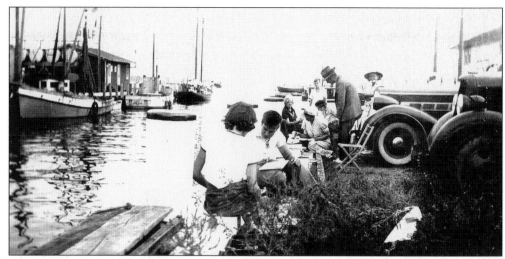

AN ART CLASS AT THE DOCK. Whitney Hubbard, a Greenport artist whose works have been exhibited at the High Museum in Atlanta, the Brooklyn Museum, the Art Institute of Chicago and the Corcoran Gallery of Art in Washington, D.C., gives a lesson to aspiring artists in the 1930s. He and his musician wife, Ruth Hubbard, were honored by the people of the village in 1951 at Hubbard Appreciation Day.

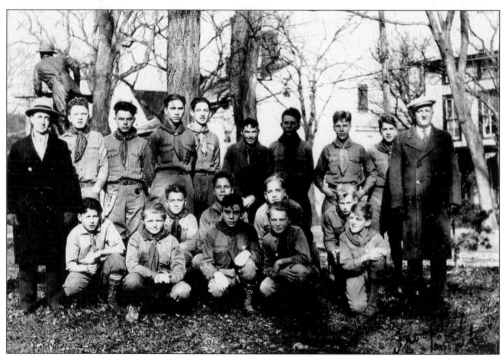

TROOP NO. 4, 1930. Greenport's first Boy Scout troop was organized by Rev. Harry Rice of Holy Trinity Episcopal Church in 1915. Troop No. 4 poses by the war monument. Included in the photograph are Scoutmaster Shirley Hawkins, Henry Hulse, and John Sherwood.

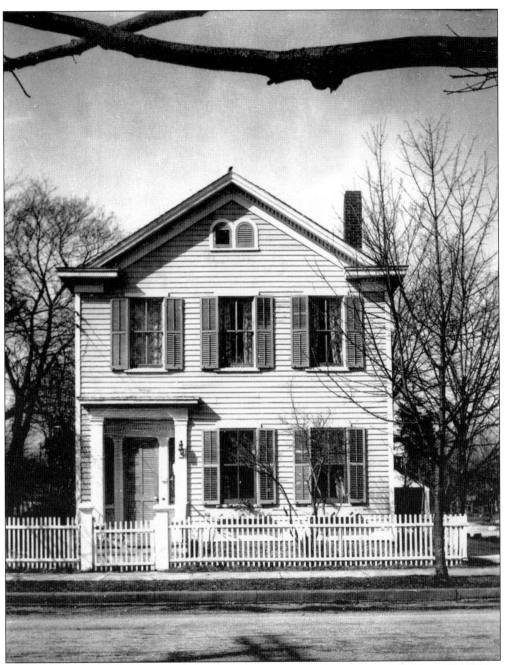

THE WHITNEY AND RUTH HUBBARD HOUSE, C. 1858. This charming house is No. 29 on the Greenport Village architectural walking tour. The house has a late–Greek Revival doorway with interestingly turned trim on the pilasters. Dentils around the eaves and door, together with the double-arch windows in the gable, give it character. Whitney Hubbard was a well-known painter, and his wife was a fine musician. Their studios were always open to students, and their garden was both a subject of paintings and a favorite hobby. Hubbard's gallery was at 207–209 Main Street, a building renovated by artist Rich Fiedler and his wife in 2002. Photographers Frank Hartley and Hugo Frey were other notable tenants in the gallery building.

Ringing Bells. The bells rang when Edith Edwards and Jack Sherwood were married at Holy Trinity Lutheran Church in Greenport on February 5, 1949. The best man and matron of honor were Fred Gardiner and Eunice Petersen, who, soon after, were also married. The Sherwoods' reception was held at the old Porky's restaurant, where Warren Bricci worked as bartender, played the violin, and made "the best onion soup in the world."

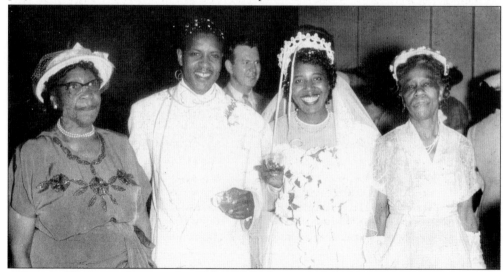

A Joyous Wedding, June 1953. Helen Walker's son, Purcell Moses Walker of Greenport, marries Martha Kelly, who stands with her mother. Helen Walker was related to the Morris family, who came to Southold town from Powhatan, Virginia, in 1922. A well-regarded local preacher, she was a member of the African Methodist Episcopal Zion Church.

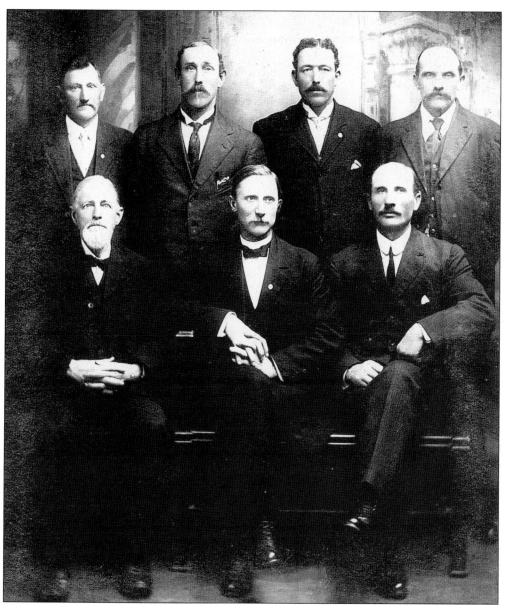

THE LUTHERAN BOARD. Germans first came to Southold town when the railroad line was completed to Greenport in 1844. The first church was informally organized by German-speaking townspeople in 1857 and officially organized in 1866. In the beginning, the parishioners held services at the Congregational church, where Floyd Memorial Library stands now. Within 20 years, there were enough Germans in the village to justify building a Lutheran church on the corner of Fifth Avenue and South Street in 1879. Frauen Verein, a ladies' aid society, raised money to build the church. J. Peter Drach, a local tobacco merchant, had already organized the first Lutheran Sunday school in 1871. The church was named St. Peter's Evangelical Lutheran Church. Also in the village there was an "all Negro" Trinity Lutheran Church, led by Peter Booth. St. Peter's Church, on Route 25, currently has the original bell from the old Congregational church, on First and North Streets. It also has a steeple that was donated in 1988 by Cora Glover Stoll in memory of her husband, Ted Stoll.

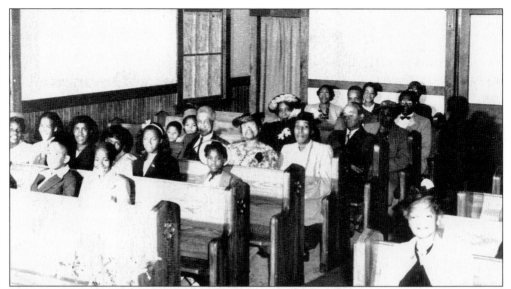

THE CLINTON MEMORIAL ZION CHURCH. Ida Shepherd (right) founded this African Methodist Episcopal church. On the aisle in the third pew from the rear is Wayland Jefferson, Southold town's first official historian, with his wife, Sarah Jefferson. Just ahead of them are Sara Birney and Harry Day and his wife. Norma Newkirk is behind the Jeffersons and, at the rear, are Floyd Davis, Helen Walker, Dorothy Atwell, and Morris Mosby.

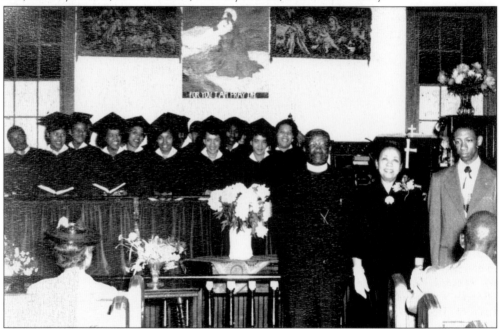

THE ZION CHURCH CHOIR, C. 1946. The choir of the African Methodist Episcopal church stands behind Rev. and Mrs. Tonsill Richards and their eldest son, Arthur Richard. In the front are church founder Ida Shepherd (left) and Craddick Jackson (right). Choir members are, from left to right, Zelotis Toliver, Francis Swann, Addy Howard, Marion Swann, Josephine Watkins, Dolores Wilson, Evelyn Davis, Vernice Wilson, Margaret Davis, and Anabel La Bad (known as "the Black Kate Smith").

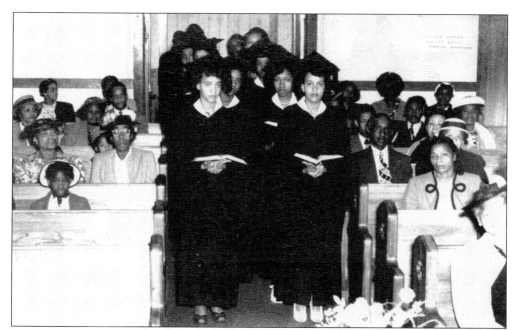

SACRED MUSIC, THE 1940S. The African Methodist Episcopal Zion Church choir sang at two services on Sundays, the 11:00 a.m. and the 8:00 p.m. Afternoon programs began at 3:00 p.m., and there was also a Sunday school and Wednesday evening prayer service. Leading the choir are, from left to right, Margaret Davis, Dolores Wilson, and Evelyn Davis. The pastor at the time was Rev. David Prince Thomas.

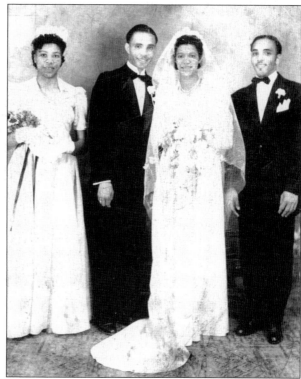

WEDDING BELLS, SECOND STREET. A happy wedding took place at the Davis home in September 1941. The bride was Dorothy Davis, and the groom was Henry C. Walker. The maid of honor was Josephine Walker (left) of Greenport, and the best man was Lewis Walker (right), who was not related to the bride. The black religious community of Greenport extends back to at least 1858, when the Chace map of the village shows an "African" church on Broad and Second Streets.

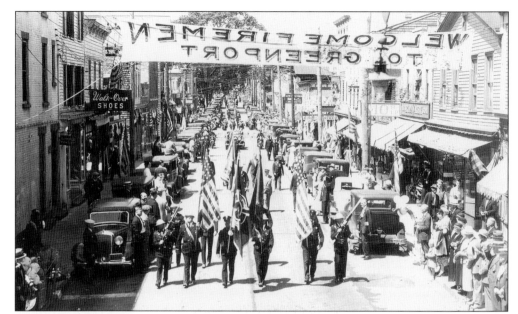

A CELEBRATION, JUNE 16, 1933. This was the more decorous part of the annual firemen's block party, when the southern New York firemen were hosted by Greenport's fire department. Earlier ceremonies began with a silly, funny, and dizzy parade, including "decrepit motor cars billowing forth clouds of thick smoke." Some firefighters marched in ragamuffin clothing to the music of the Stynkopators, of the Star Hose Company.

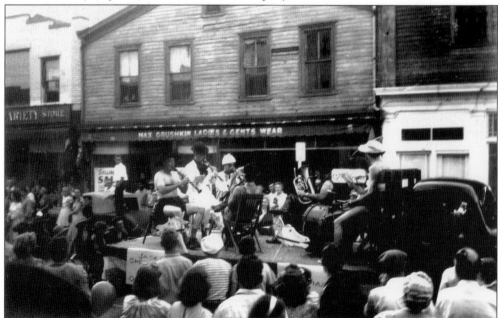

BUGHOUSE PARADES. Impromptu parades, such as this one, were connected with the fire department and conceived on the spur of the moment for fun. Jack Sherwood's band is on Front Street in front of Max Grushkin's Ladies' and Gents' Wear, with the Arcade Variety Store to the left and Isabelle Conklin's hosiery shop to the right. Carl Cooper and Bill Quinn are among the performers.

Five

ARCHITECTURE

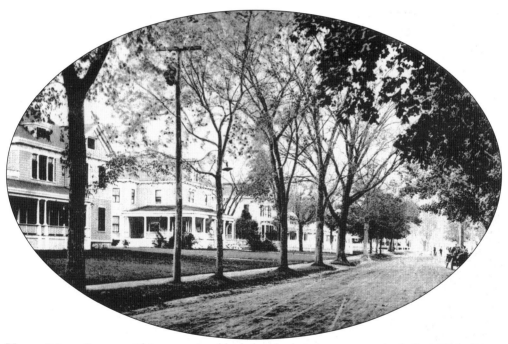

UPPER MAIN STREET. This attractive block has had various names, including High Street because of its elegance and Captain's Walk for several whaling captains who lived here in the 19th century. It was also called Murray Hill to suggest one of Manhattan's more posh residential areas. In later years, some of these stately homes became bed-and-breakfast establishments. Broadway stage designer Peter Larkin called this "the nicest part of Greenport," but there are many competitors for that title. *A Guide to Historic Preservation in Greenport Village*, published in 2002, describes several styles of architecture that predominate in Greenport: Greenport Vernacular (the common style), Greek Revival, Italianate, Second Empire, Queen Anne, Late Victorian, Shingle, and Bungalow. The pamphlet also includes "Recommendations for Homeowners" from the Greenport Historic Preservation Commission.

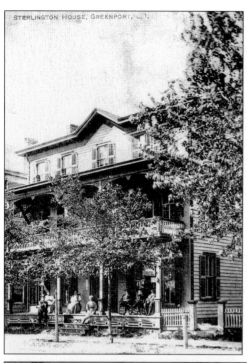

A Railroad Hotel. This extravaganza of a building was called the Burr in the mid-19th century but was renamed the Sterlington Hotel in 1894. Convenient for rail passengers, it was a boardinghouse for summer visitors and rail workers until 1980, when a Mexican restaurant opened on the ground floor.

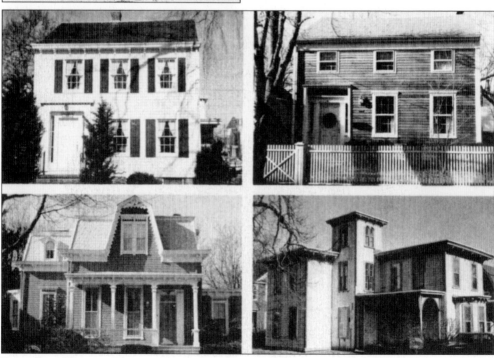

Four Fine Houses. The *c.* 1831 Stirling Historical Society building (upper left) was moved from the south side of Adams Street in 1976. The *c.* 1828 house (upper right) stands on Second Street; it was once the home of playwright Paul Foster. The *c.* 1874 house (lower left) is on First Street. The *c.* 1870 house (lower right) sits on Main Street; it was once the home of a Captain Wells, who became a slave trader and disappeared at sea.

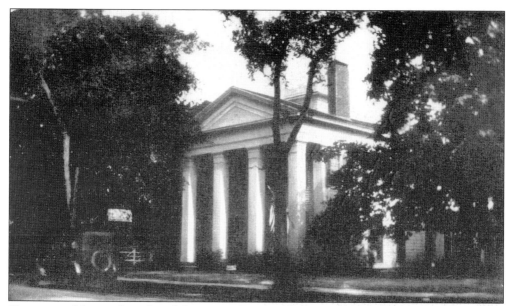

TOWNSEND MANOR INN. Joseph Lawrence Townsend, descendant of one of the oldest families in America, decided to sell his farm in East Williston and retire to Greenport. Nine years after his death in 1916, his widow, Lillian Cook Townsend, bought the stately Cogswell residence. Impressed with its dignity and charm, she converted it to an inn. Furnished according to the period, the inn still speaks of Greenport in earlier days.

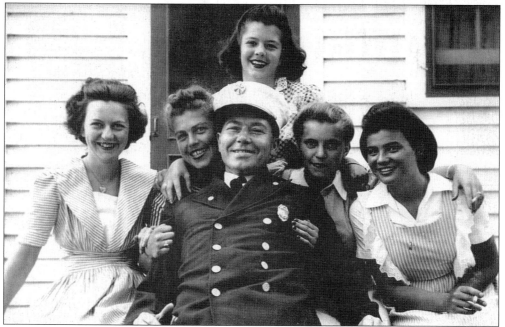

IT's A BOY. Joseph Townsend Sr., in a volunteer fireman's uniform, rejoices on July 1, 1945, at the birth of his son, Joe Townsend Jr. Some 28 years later, the son was elected Greenport's youngest mayor. The young women with Joseph Townsend Sr. waited tables at the family's restaurant. From left to right are Ellen Rogers, Doris Stelzer, Jean Webb, Lois Hallock, and Antoinette Fiore. The inn was sold to the Gonzalez family in 1950.

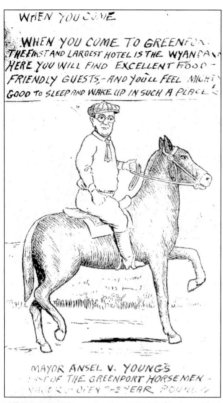

STAGECOACH STOP. Ansel V. Young, Greenport village mayor, bought the venerable Wyandank Hotel in 1920. Located on Third Street, the hotel began in 1845 as a public inn for weary travelers. It had a taproom and stables for horses attached to the rear of the building. The Wyandank was in operation for over 120 years, and its food and hospitality were legendary.

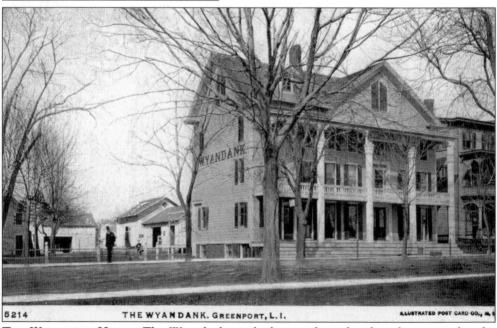

THE WYANDANK HOTEL. The Wyandank was built near the railroad tracks a year after the Long Island Rail Road came to Greenport. Across the street was Peconic House, built the same year. In 1857, S.P. Conklin was the proprietor; however, the 1858 Chace map and the 1873 Beers atlas show the property was owned by J. Terry. The hostelry was torn down in 1968.

Main Street showing Presbyterian Church, Greenport, L. I.

MANY YEARS OF MINISTRY. Organized on February 7, 1833, the Greenport Presbyterian Church completed its building on Main Street in 1836. Among the names of the first preachers were Ketcham, Beers, Huntting, and Saxton. The church closed on December 31, 1979. Since 1981, this has been the Greek Orthodox Church of SS Anargyroi and Taxiarhis.

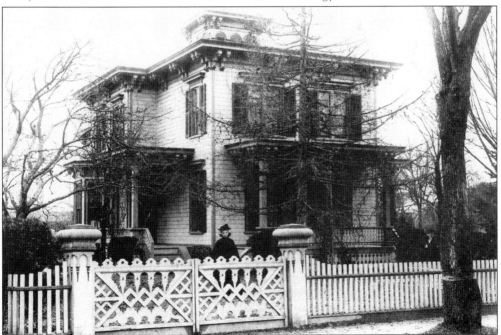

THE LYONS HOUSE. This 1903 photograph shows the home of George Lyons and family, on Bay Avenue in Greenport. The Lyons operated a dry goods store in the village for 53 years. Their son Charles Lyons, a lawyer, married Rose Krancher, and their daughters Eloise, Kate, and Mary worked at the L.E. Lyons and Company store, on Main Street.

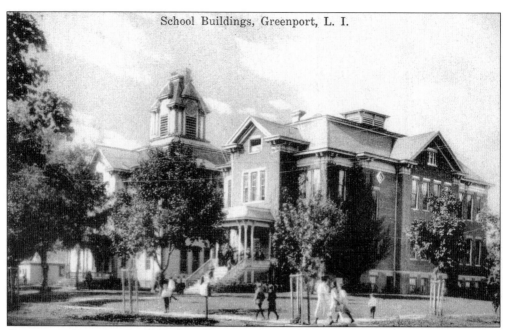

GREENPORT SCHOOLS. In 1860, the village voted to establish a union free school district and to pay teachers up to $500 a year. Faced with an ever-increasing population, Greenport taxpayers voted in 1878 to buy land to build this three-story, frame grammar school. The high school was built in 1904 and was added to in 1910.

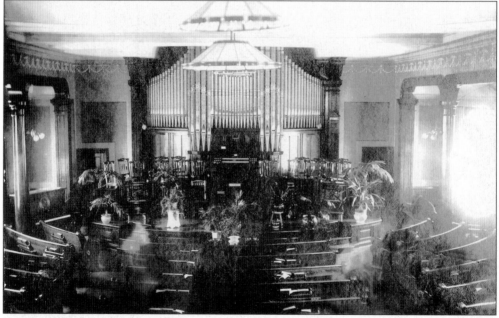

THE FIRST BAPTIST CHURCH. This was the first church erected in Greenport. It was originally organized in Rocky Point (now East Marion) and built in 1833 in Greenport, on the corner of the North Road and Main Street. It was moved to 650 Main Street in 1844. By 1845, the church had 151 members. This picture shows the electrical fixtures installed c. 1887, only eight years after Edison's discovery of a commercially viable incandescent bulb.

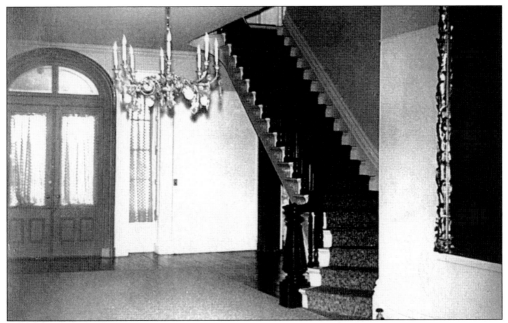

THE MAIN ENTRY HALL. The regal staircase of the David Gelston Floyd manor house was completed in 1857. The bearing walls of the house are three feet thick, and each window has inside folding panel shutters. The Floyd family made its fortune, in part, by whaling. The house, on the North Road, became the centerpiece of Peconic Landing.

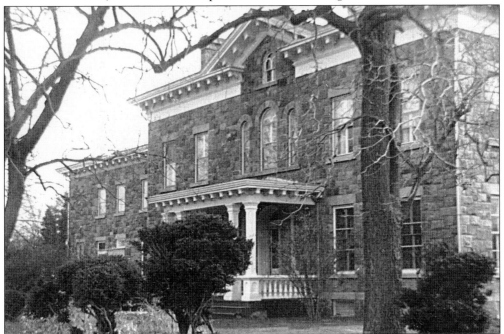

A REAR VIEW. This is not the usual view of the palatial stone home of the Floyds. David G. Floyd was the grandson of Gen. William Floyd, member of the Continental Congress and signer of the Declaration of Independence. The manor house was built from stones quarried on the grounds by Scottish stonecutters. (Photographs by James Monsell.)

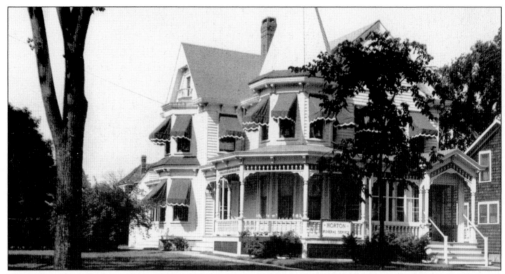

THE HORTON FAMILY BUSINESS. J.E. Horton and his son, S.B. Horton, established a funeral home and furniture store before 1862. At first, they made the furniture and caskets they sold. In the early 1940s, the Hortons purchased the former Otis Corwin homestead, on First Street, for the funeral parlor. In 1950, they enlarged the furniture business at 315–321 Main Street. In 1973, that store became the property of the Eastern Long Island Hospital Association and the home of the Opportunity Shop.

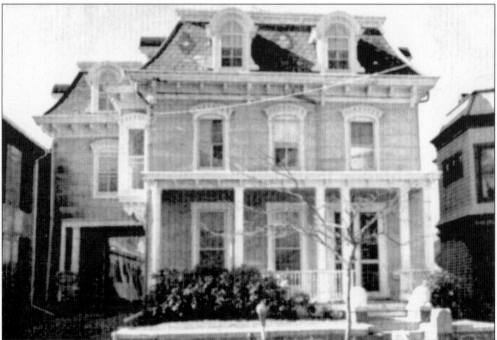

THE PHILLIPS HOUSE. Wells Philips was the original builder and owner of this Main Street home. The house was bought in 1924 by Samuel Levine, who, learning that he would have to get his neighbor's permission to drive through to the back of his house by way of the next-door driveway, had builders cut through a large sitting room on the ground floor and pave a drive to his backyard garage. Levine's widow, Essie Levine, lived in the house until her death in 1974.

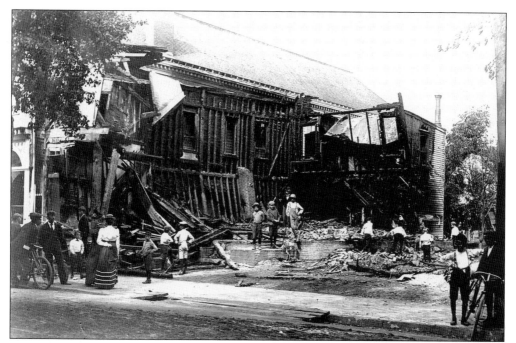

A FOUR-ALARM FIRE. Disasters such as this one on Main Street at the beginning of the 20th century gave Greenport firemen plenty of opportunity to show themselves as heroes to the community. This particular building was between the Greenport Auditorium and the home of Dr. Clarence C. Miles and his family. Today, the property is the site of the Masonic temple.

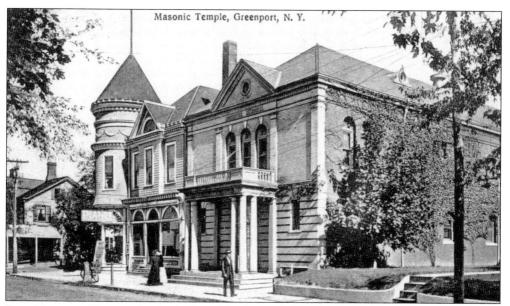

Masonic Temple, Greenport, N. Y.

THE MASONIC TEMPLE. In the lobby of the Masonic temple, on Main Street, is a portrait of William Johnston, a wealthy New York merchant who retired to Greenport and left $10,000 (then a princely sum) to build the hall. The stately building was dedicated on April 11, 1903. It is the home of Masonic Lodge No. 349, Royal Arch Masons No. 216, and Sterling Chapter, Order of the Eastern Star No. 216.

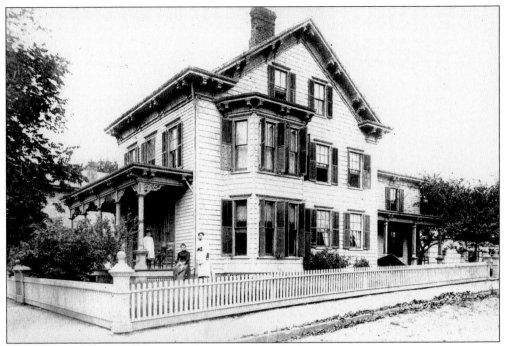

THE HOME OF GEORGE REEVES. George Reeves was a very successful local businessman who at one time owned most of the east side of Main Street, as well as the lumber company that bore his name. This building became Arnott's Drug Store, and in 1988, it became the Doofpot.

A STATELY HOME OF GREENPORT. This was once the home of Grace Floyd, granddaughter of William Floyd, a signer of the Declaration of Independence. The oldest part of the house was located on Sterling Creek before it was moved to its present location, next to Peconic Landing on the North Road. A section of the original house was moved to Knapp Place and became the home of local history buff Frank "Sparky" Coyle.

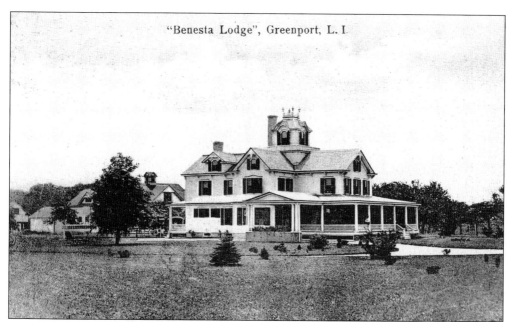

"Benesta Lodge", Greenport, L. I.

MISS HAVISHAM WOULD HAVE LOVED IT. Benesta Lodge, on the North Road, was like something from Charles Dickens's *Great Expectations*. It was the summer and weekend home of the Faulkner family. Faulkner was a successful engineer. As the years went by, the lodge became derelict. It was torn down in the 1990s.

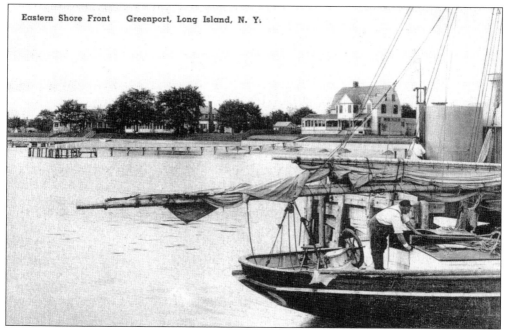

Eastern Shore Front Greenport, Long Island, N. Y.

SHOREFRONT PROPERTY, GREENPORT HARBOR. This boat is nosed into the Long Island Rail Road dock. The 1909 *Belcher-Hyde Atlas* shows the large house to the left as part of the W.F. Chrystie estate, with Edward Miller's residence in the back, on Fourth Street. Houses next on the left were those of John J. Bartlett, J.W. Maynard, C.B. Crane, and last, the Coffee estate. Between the Coffee and Crane properties was a small basin known locally as Widow's Hole.

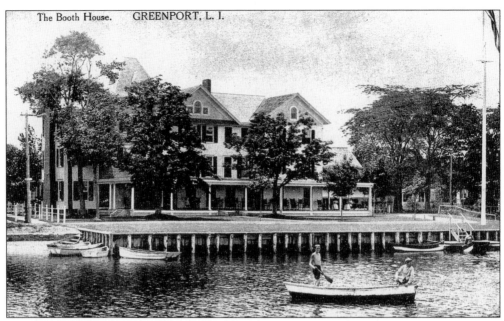

The Booth House. GREENPORT, L. I.

THE BOOTH HOUSE, STERLING CREEK. This house is not to be confused with the Constant Booth Inn, which was moved from Greenport to Orient and had its name changed to Webb House. The Booth House was a typical summer hotel, built in 1877. From November 1942 to February 1943, it was used by the U.S. Coast Guard as a base for the Greenport Coastal Picket Patrol. The building reopened as a hotel in May 1944.

A DOLL MUSEUM. This spacious Greenport house, on the northwest corner of Broad and Main Streets, was for many years the home of Fred Corey of the First National Bank. In the mid-20th century, it was purchased by lawyer Frank McMann and his wife. From 1968 to 1992, Mrs. McMann and her daughter, Carla, ran the charming Museum of Childhood, which featured a toy village and annual tea parties.

A LOST GEM. The impressive Opera House, at Bay and Main Streets, replaced Stirling Hall, which burned in 1899. Inventor Frank Hartley showed films here. One night in December 1911, Hartley's projector caught fire, and the flames quickly spread to the front of the building. Although the building was saved, a much-changed Opera House continued to operate until it was torn down in the mid-20th century. The site later became a parking lot for the Bank of New York.

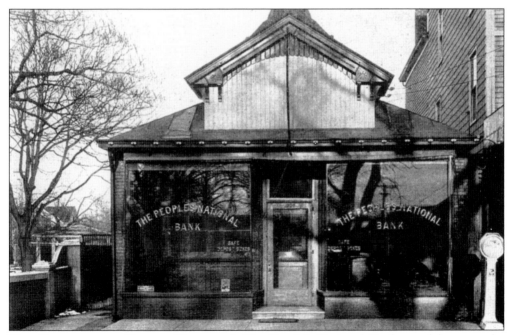

THE BANK OF THE PEOPLE. The pagoda-like People's National Bank stood between the stately Klipp home and Hochheiser's five-and-dime store, on Main Street. In 1930, the bank's president was David W. Tuthill and its cashier was Irving L. Price. The bank site, as well as the Klipp house, became a parking lot for the North Fork Bank.

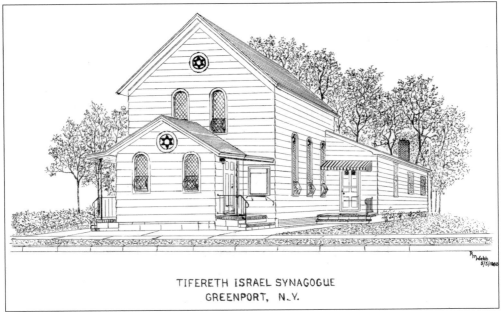

TIFERETH ISRAEL SYNAGOGUE
GREENPORT, N.Y.

SERVICES FOR THE CONGREGATION. Before the temple of Tifereth Israel was chartered in 1902, services were held in members' homes. In 1903, the Orthodox congregation acquired a lot and built a modest, attractive synagogue. The temple was added to in the 1920s, in 1964, and again at the beginning of the 21st century. The congregation became Conservative, with an active Hebrew program for youth and diverse activities conducted by the Daughters of Israel.

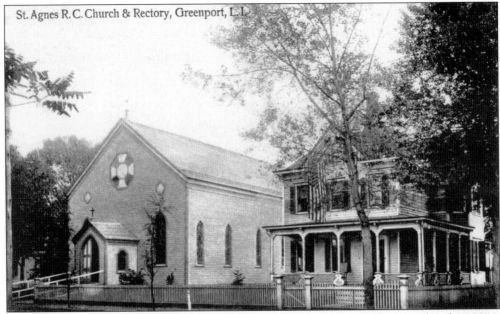

St. Agnes R.C. Church & Rectory, Greenport, L.I.

A NEW PEOPLE AND A NEW RELIGION. Both came to Greenport with the railroad in 1844, when Irish rail workers settled in the village. As the numbers of these newcomers increased, land was purchased in 1855 for a Catholic church—a small, plain single-story building fronting on Sixth Street. The church was later named St. Agnes. Early church trustees were Patrick Burns, Patrick Lennon, and Andrew Cassidy.

Six

TRANSPORTATION

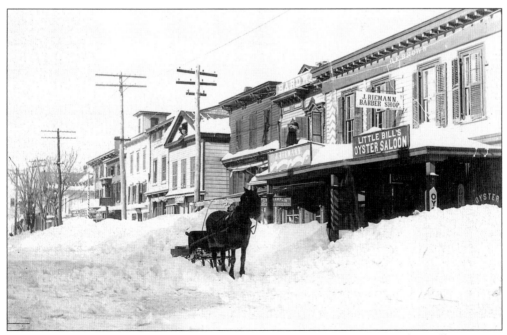

LITTLE BILLY'S OYSTER SALOON. Of necessity, walking was the most common form of locomotion in early Greenport. For those more fortunate, there were horses. Each hotel had attached stables, and there were liveries for the hiring out of horses and carriages. Most professionals owned their own teams, and many village buildings had mounting blocks out front.

CONNECTING LINKS. Trains met the Long Island Sound steamers, providing smooth travel between Connecticut, Greenport, Shelter Island, and Sag Harbor. This well-orchestrated schedule from 1881 would be much appreciated today, over 120 years later. Not only was the timing exact, but freight was shipped at low rates and meals were only 50¢

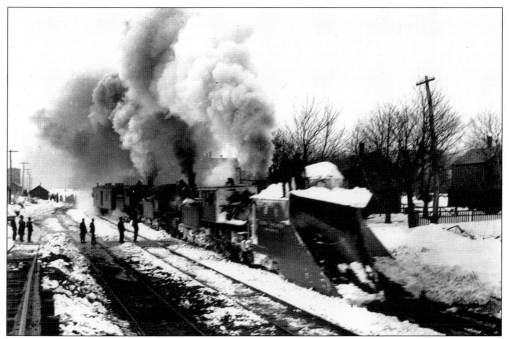

A Vital Link. A train clears snow from the tracks of the Long Island Rail Road. The railroad was resented by many when it first came to Greenport in 1844. Farmers protested that almost every farm between Riverhead and the village was cut in two, cattle wandered onto the tracks and were killed, sparks from the engines started fires, and soot soiled clothes hanging outdoors to dry.

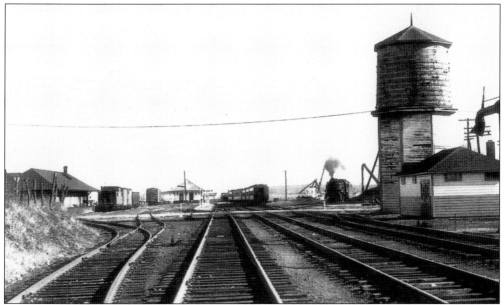

The End of the Line. The Long Island Rail Road's water tower was used to fill steam engines, and the turntable enabled them to head back west. To the right rear are the ferry and the new dock, built in 1873. Watching the train come in was a recognized pastime. The *Cannonball Express,* which arrived complete with parlor car, was a popular attraction.

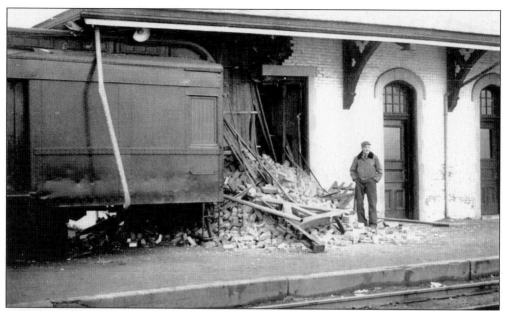

ASLEEP AT THE SWITCH. A freak accident occurred on February 18, 1949, when the six end cars of a Long Island Rail Road freight train became detached while switching on the spur north of the main track in Greenport. The cars headed with great force for the station, where ticket agent Roy Platt and express agent Frank Coyle were at work. "Sparky" Coyle alerted Platt, and the two were no sooner out of the building than the train crashed through the southwest corner of the station.

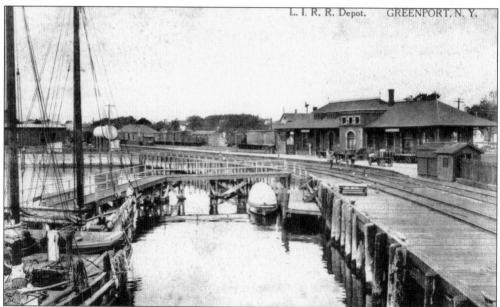

L. I. R. R. Depot. GREENPORT, N. Y.

A BIG CHANGE. Before the arrival of the railroad in 1844, Greenport was a seafaring place with many whaling ships registered to the port. Trips to New York or Brooklyn took several days by sloop or stage. In its prime, the railroad carried not only passengers and mail but also oysters and other seafood to distant restaurants. In 1936, the busy offices of Railway Express shipped two and a half million oysters.

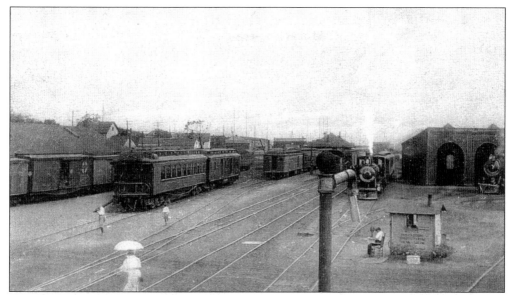

THE YARDS. The Greenport railroad yards *c.* 1910 were a bustling spot, with visitors and goods arriving daily. Nearby, the New London boat docked at the foot of Main Street and carried local youths across Long Island Sound to enjoy Ocean Beach. The freight station pictured just past the cars at the left has become an interesting railroad museum with an informed volunteer staff.

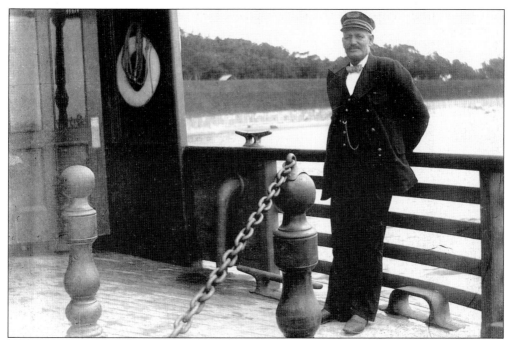

AN OLD SALT. Capt. Willard Fillmore Griffing was captain of the *Menantic*, which was launched in 1893 to run between Shelter Island and Greenport. There was room on the main deck of the boat for eight teams and wagons, with two passenger rooms on either side. In addition, there was a saloon on the upper deck and a promenade deck circling the saloon. Griffing, who followed the water all his life, was president of the village during World War I.

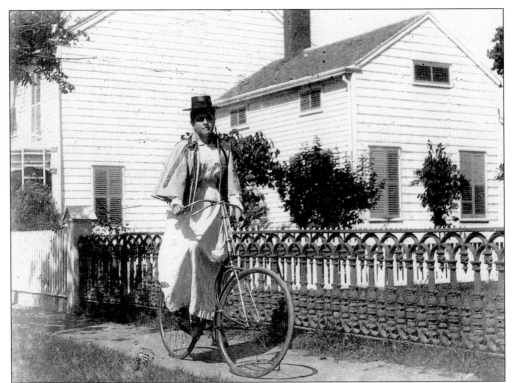

AN EARLY AEROBICS PROGRAM. Henrietta M. Terry of Main Street sits on her bicycle in front of a house on the northeast corner of Broad and Second Streets. In later years, it was the home of Gladys Pemberton, an art teacher and, later, the capable director of Floyd Memorial Library. Bicycling was an immensely popular activity in the village and an important mode of transportation.

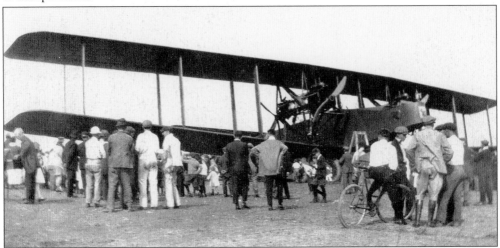

OUT OF GAS. In October 1919, this English Handley-Page biplane landed on Burt's farm, just west of the village, when it ran short of fuel. It was on a nonstop trip to Chicago for the American Railway Express Company and attracted countless curiosity seekers. Three weeks later the biplane was seized by U.S. customs officers in New York for nonpayment of the customs duty on large aircraft.

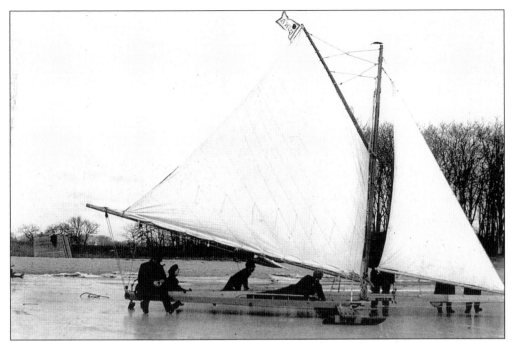

ICEBOATING. This is still a popular winter sport—a means of locomotion rather than transportation, although local residents have often used iceboats in imaginative ways in order to get from one place to another. The site is most likely Gull Pond, as the shoreline is shallow and the downward incline into the bay is very gradual.

Suffolk Road. GREENPORT, L. I.

SUFFOLK ROAD. This was the name given to Route 25, or the Main Road, in the 19th century. It is easy to forget that all local roads were unpaved at one time, making passage difficult, especially in wet or snowy weather. This road, with its milestone reading, "1 m GR" (one mile to Greenport) is in relatively good condition. The Greenport information booth would be near the left margin.

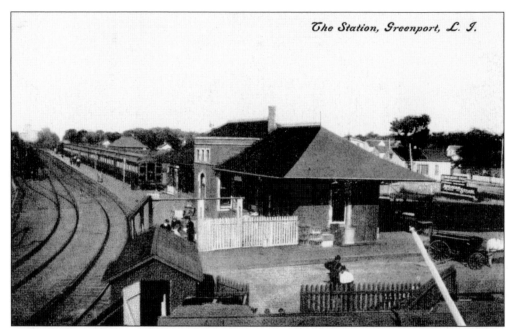

DESTINATION GREENPORT. The first train to Greenport, meant as a link to Boston, ran on June 27, 1844. This well-kept brick railroad station at Greenport epitomized an era of growth on Long Island, when as many as eight trains a day came through Southold town. By 1965, the increased use of cars and trucks caused the decline of passenger and freight service on the North Fork.

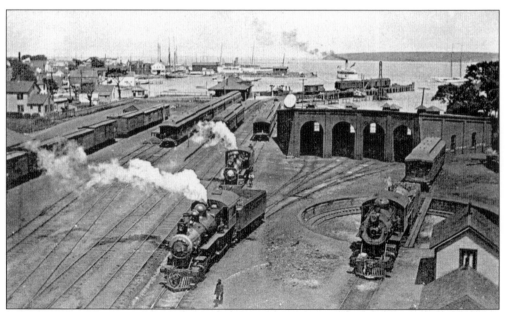

THE RAILROAD YARDS. This is Greenport's busy transportation hub, where the ferry and the train met in the 20th century and where they continue to meet in the 21st century, with the addition of the Sunrise Coach Lines. The casings used in the turntable (lower right) date from 1898. Although dated *c.* 1905, the photograph may have been taken earlier.

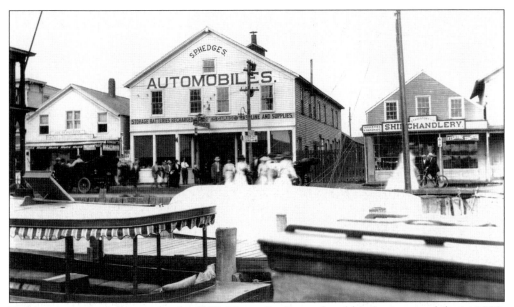

INVENTION AND INNOVATION. In 1893, Henry Ford completed his first automobile; in 1903, he founded a motorcar company; in 1913, he began using an assembly line. The success of the motorcar in Greenport owed a lot to the local popularity of the bicycle, which had resulted in vastly improved local roads. Schiavoni's Market is to the left of S.P. Hedges's automobile dealership, on lower Main Street, and the small S.T. Preston chandlery on the right.

OUT FOR A SPIN. Edna Hedges was the bookkeeper of S.P. Hedges's car dealership and the proprietress of a popular boardinghouse, which sheltered teachers in winter and wives of fishermen in summer. Her establishment was located on Fourth Street, next to Congregation Tifereth Israel. The site is now dedicated to the memory of Andrew Levin, who, with his sister Rachel, operated the Soundview Restaurant and Inn.

COUNTING THE CARS. This view illustrates life on lower Main Street *c.* 1950 (and the merchants think they have parking problems now). The Shelter Island ferryman stands on the wooden sidewalk of Preston's while he determines the capacity of the next crossing. The street was so clogged with traffic that eventually all ferry operations were relocated to the railroad dock.

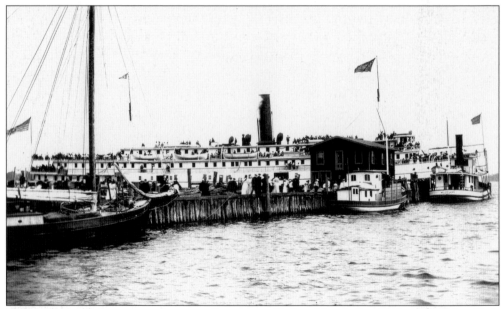

ALLIES. Summertime service between Greenport, Shelter Island, Sag Harbor, and New York was provided by the Montauk Steamboat Company in cooperation with the railroad. The Long Island Rail Road owned 62 vessels in the early 20th century. Two iron steamers, the *Shelter Island* and the *Montauk*, were 175 feet long with a 31-foot beam, and each had more than 40 staterooms.

Seven

DIVERSIONS

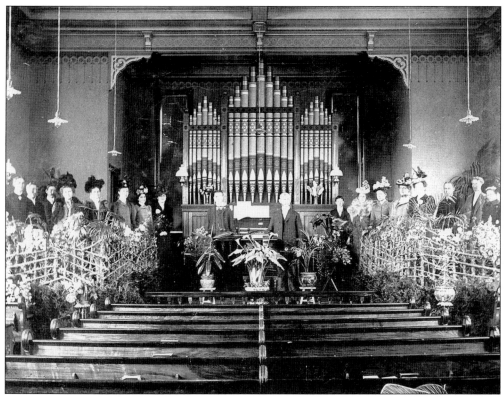

VITAL TO THE COMMUNITY. It is hard to overestimate the importance of church and synagogue in the shared life of the village. Weddings, funerals, and revivals all helped weave the strands of the Greenport community together. In this *c.* 1910–1920 view, Methodist church members and the choir are decked out in Easter bonnets. The sanctuary remains much the same today.

BRIGHT YOUNG THINGS. These young women, posing for a fashion show, faced many changes in the 1920s. The *Suffolk Times* remarked, "Autocracy has come to an end," and predicted that hundreds of women in Suffolk County would soon vote for the first time. Editorially, the paper chided, "There is nothing smart in this brazen way of dressing, why don't the girls think twice before they do it?"

WELL-DESERVED RELAXATION. Red-shirted Greenport firemen and their women enjoy a social occasion. Then, as now, North Fork fire departments relied solely on volunteers. Invitations were extended to many other fire departments for the annual Washington's Birthday parade and drill. The contests engendered enthusiastic competition.

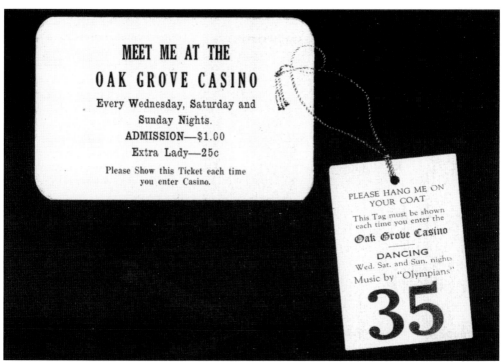

MEET ME AT THE
OAK GROVE CASINO

Every Wednesday, Saturday and
Sunday Nights.
ADMISSION—$1.00
Extra Lady—25c

Please Show this Ticket each time
you enter Casino.

PLEASE HANG ME ON
YOUR COAT
This Tag must be shown
each time you enter the
Oak Grove Casino

DANCING
Wed. Sat. and Sun. nights
Music by "Olympians"

35

DANCING THREE NIGHTS A WEEK. In 1907, a dance pavilion was erected on the bay at the end of what was then called Cherry Lane (now Ninth Street). Bathhouses and a small wharf for pleasure boats were built. The original plans were to serve shore dinners to "lovers of the light fantastic," but there was difficulty with the property's owner about serving liquor. Eventually, plans went ahead for a bay beach and casino, the Oak Grove Casino, where young women disported themselves during the long summers. At the end of each summer, winners of the Wednesday evening dance contests staged one final contest. World War II ended this paradise, as so many of Greenport's fine young men of dating age were in the armed forces.

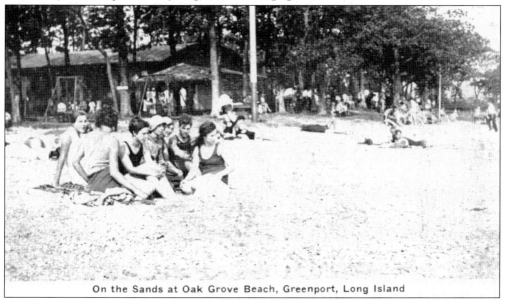

On the Sands at Oak Grove Beach, Greenport, Long Island

"AT HOME." These well-dressed members of the Cook family, like other people in former times, knew how to create their own amusements. This appears to be a mini-magic show with family members giving it their all. Lillian M. Townsend was one of the Cook daughters.

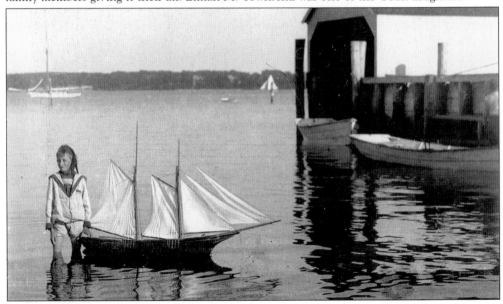

A SUMMER HOLIDAY. L. Haywood Cook Jr. is shown as a youth near his father's fish factory, on Shelter Island, with Peconic Bay in the background. He proudly displays a model of a Grand Banks schooner, which was purchased many years later from his estate by Mayor David E. Kapell.

FAMED STAGE ACTOR AND SUMMER RESIDENT. William Gillette was a major influence in the American theater. According to Elsie Knapp Corwin, "from the 1870s to the 1930s he helped change the whole direction of the American stage." Gillette wrote or adapted more than 20 plays and he played Sherlock Holmes just as Conan Doyle created him, drug use and all. For over a decade, he spent summers living on an elaborate houseboat in Greenport Harbor. In 1914, Gillette bought a plot of 25 acres known as the Chauncey Farm, on Peconic Bay at East Marion. Gillette Drive is named for the actor. He eventually sold his East Marion property to build Gillette Castle in Connecticut. During the Great Depression, members of the Preston family in Greenport traveled to Connecticut to help in constructing the famous castle.

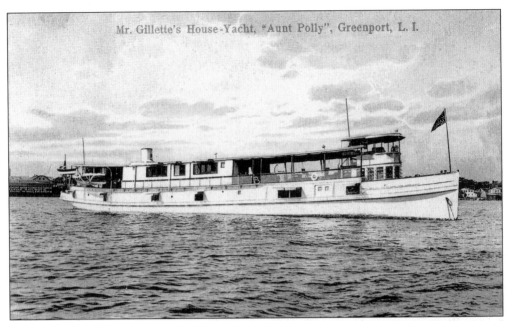

Mr. Gillette's House-Yacht, "Aunt Polly", Greenport, L. I.

A SUMMER RESIDENCE. The spacious houseboat *Aunt Polly*, moored in Greenport Harbor, served as actor William Gillette's home each summer in the 1920s. Walter Prince of Southold was fireman, and Marshall A. Monsell was engineer of the boat. Gillette's houseboy often took the actor's cat for rides through the village in a baby carriage, to the delight of residents and visitors.

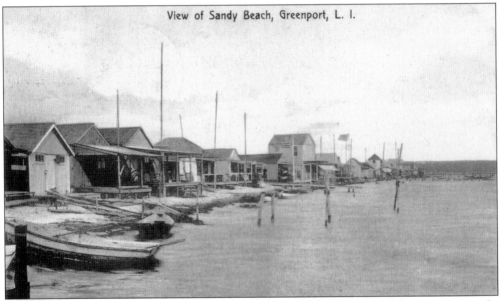

View of Sandy Beach, Greenport, L. I.

THE GOOD OLD SUMMERTIME. Sandy Beach was first used for picnics and daytime outings. In 1896, it became a small summer resort when several scallop houses on the beach were fixed up as cottages for a few Greenport families. Eventually, there were about 30 cottages whose owners formed the Sandy Beach Association in June 1932. The area across from the beach on Sterling Creek was known as Georgetown because George Corwin, George Conklin, and George Hammond all had homes there.

A LOST PARK. Prentiss Park was on Third Street near the railroad station, across the street from the Wyandank Hotel. It is shown at the edge of what became Mitchell Park. The bandstand was moved to the old school on South Street. Beyond the bandstand is the Greenport Oyster Company (left), which was badly damaged in the 1938 hurricane. The owner of the Wyandank, Ansel V. Young, was a descendant of Ansel Van Nostrand, Walt Whitman's brother-in-law.

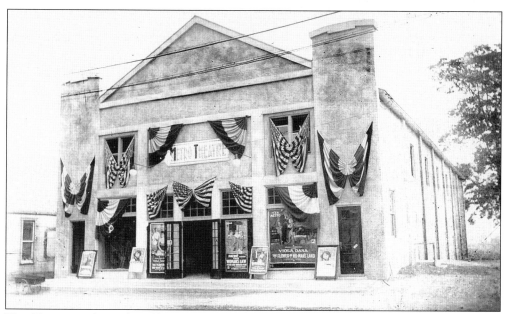

THE FLICKERS. A top-line film attraction is shown at the Greenport Theatre in 1916. In the *Flower of No Man's Land*, Viola Dane, 19, was a top star but, like many silent screen stars, she could not make the transition to sound. The *Suffolk Times* had a weekly column about the movies, reflecting their popularity as entertainment. Mayor John Kluge's garage is to the left of the theater.

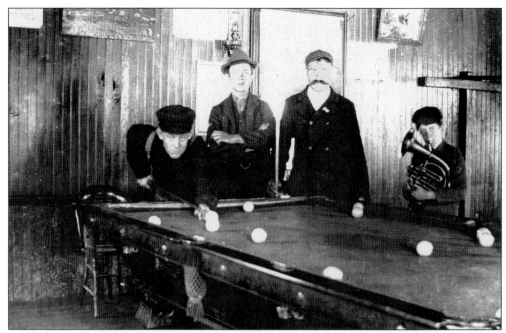

A Magnet for Tourists. As early as the 1870s, when Claudio's was established, visitors were attracted to Greenport. Poolrooms were only one of the many forms of amusement available in the village. A brass band and a cornet band played at concerts and parades, and many Greenporters owned trotting horses, using Main Street as a speedway. Stirling Hall provided entertainment, and the Flack Building staged plays and operettas.

NOTHING

WILL PUT A

BOY IN TOUCH

WITH THE

SALOON
QUICKER

THAN A

CIGARETTE

A Temperance Town. The temperance movement was active in Greenport, a village of many churches and even more saloons. Between 1877 and 1887, the Prohibition party had many supporters, and church affiliated temperance societies held weekly, well-attended meetings. There was also a secular, workingmen's organization, the Washingtonian Total Abstinence Society, established in 1842 and active until 1924.

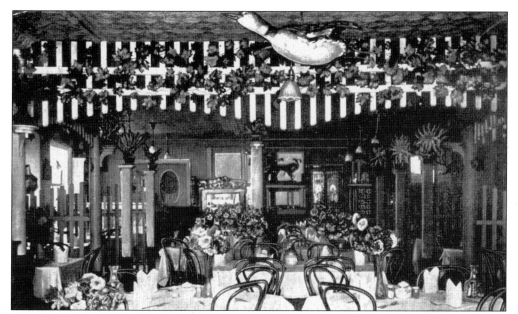

STEVE'S VIENNA RESTAURANT. Located on Front Street, this restaurant had elegant service, provided by tuxedoed waiters. Douglas Fairbanks and Mary Pickford, Hollywood's power couple of the 1920s, motored from Manhattan to dine here. Above was a hotel with 20 rooms. Stephen Cvija was host. In 1947, new owner Edward McComber changed the name to Hotel Greenport. It was later known as Helen's Bar and Grill. Before 1910, the building was the home of Samuel Moore and family.

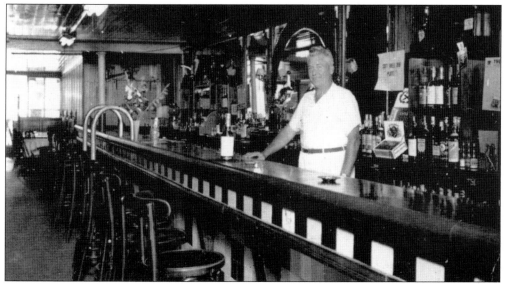

A POPULAR WATERING HOLE. Bill Worth's Rendezvous, originated by Joe Kalbacher, was a lounge for fishermen and sailors. The Worth family ran the fabled Worthwhile speakeasy in Peconic during Prohibition. After the repeal of Prohibition, Bill Worth moved to Greenport, where his saloon could have passed as a set for a Eugene O'Neill barroom drama. Worth sold Chinese food—a real novelty in "a meat, potatoes, and whiskey" town.

121

AN IDEAL SODA SHOP. The mythic soda shop of the past comes alive in this picture of Paradise Sweets Restaurant and Tea Room, opened in 1923 by George P. Mellas. Mellas was killed in an automobile accident in 1936 at the age of 36. The restaurant was then sold to Peter Pappas of Sag Harbor.

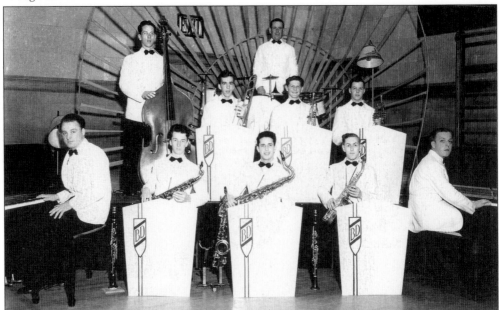

SOPHISTICATED SWING, JUNE 1938. This band, called the Bob Dennis Orchestra, was formed at Greenport High School. The group broke up in 1938, when some members either left for college or enlisted in the service. Included in the photograph are Sherrill "Rip" Pemberton, Jack Sherwood, Bud Morris, Lawrence "Zuker" Klipp, Rod Van Tuyl, Irving "Izzie" Hoppen, Ernest Rowland, and Arthur "Bo" Hulse.

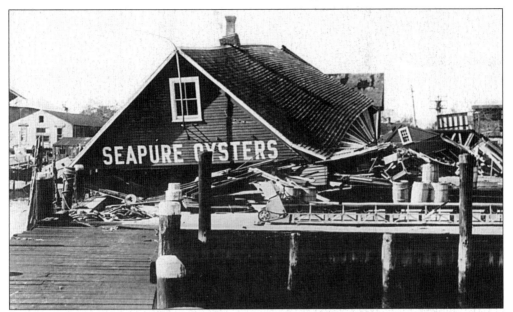

"THE GREAT NEW ENGLAND HURRICANE." That is what the September 1938 hurricane came to be called. The storm uprooted over 600 trees in Southold town within two hours and caused thousands of dollars worth of damage along Greenport's shoreline—wrecking shipyards, tearing the roof from Eastern Long Island Hospital, flattening the Greenport Theatre, and toppling the Greenport Oyster Company's building behind Mitchell's Restaurant.

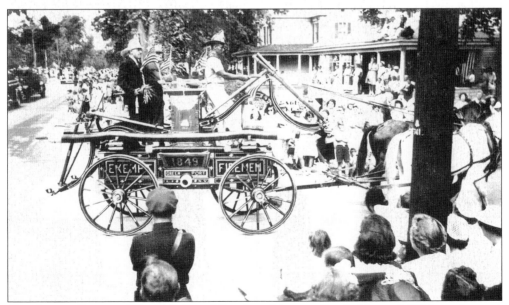

THE OLDEST PUMPER. The 1940 Grand Parade, celebrating Southold town's 300th anniversary, included the Greenport Fire Department with its 1849 pumper. In that year, the Game Cock Fire Company was formed in the village. A scant five years later, Greenport had a dreadful fire that destroyed many buildings near the corner of Front and Main Streets. Men and women formed lines to pass buckets filled with bay water.

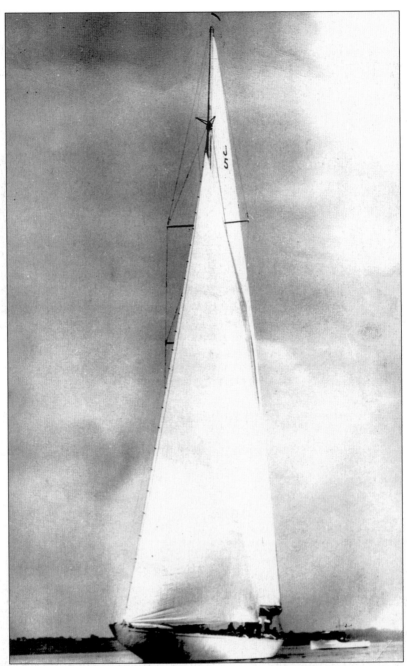

THE RANGER. This is the 1937 winner of the America's Cup, skippered by Capt. George Monsell of Greenport. Many crew members were local men, and the famous ship was maintained at village shipyards. Civic pride was greatly enhanced. According to Stone and Taylor's *America's Cup Races*, "the 1937 series had been a happy one. The challengers had become resigned to their fate before it ended as a result of 'Ranger's' obvious superiority. There were no over-stretched nerves, no protests or unpleasant incidents. Everybody connected with the rival yachts were firm friends when it ended." America's Cup races were called off after 1937, because of the approaching war. They did not resume until 1958.

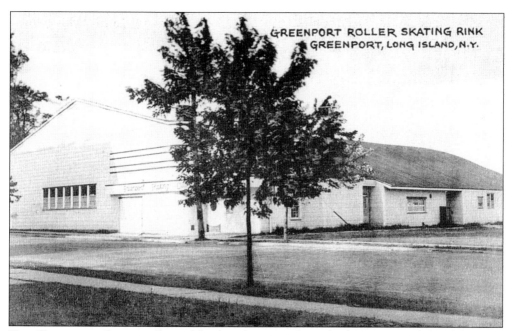

THE GREENPORT SKATING RINK. The first skating rink was built in 1939. It burned down on January 20, 1953. The building was also the American Legion Hall, and the Legion rebuilt it shortly afterward, with meeting rooms for members on the second floor. This was the scene of the grand party celebrating Greenport's 150th anniversary.

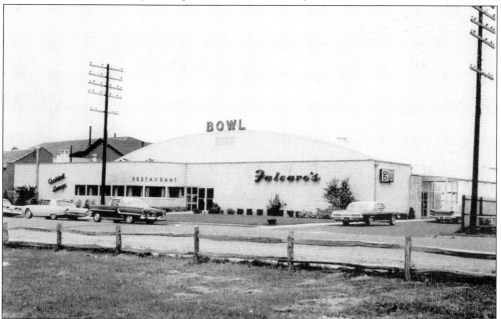

"MODERN ACHIEVEMENT." In 1962, Frank Falcaro built this 24-lane bowling alley and restaurant on Moore's Lane near Route 25. In time, the building became storage for Jernick Moving Company, as well as the home of the Catacombs, a youth center run by the Southold Town Narcotics Guidance Center. When it was destroyed by fire in the 1970s, many local people lost cherished possessions.

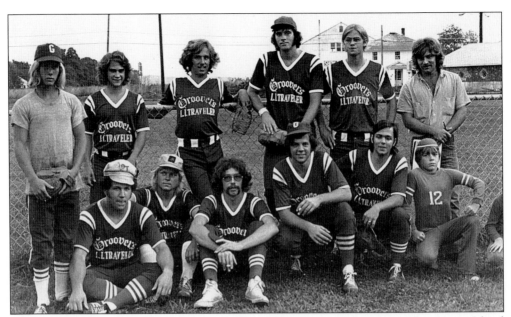

THE GREENPORT SOFTBALL LEAGUE. The Groovers, sponsored by the Long Island Traveler-Watchman, played in the league during the 1970s. From left to right are the following: (front row) Pete Checklick, Jim Sage, Jim Travers, John Bunchuck, Steve Witherspoon, and unidentified; (back row) Paul Moeller, Steve Angona, Jeff Citera, Joe Potorski, Dave Witherspoon, and Jack Citera. The league, which continues to thrive, is yet another manifestation of how important sports have always been in Greenport's history.

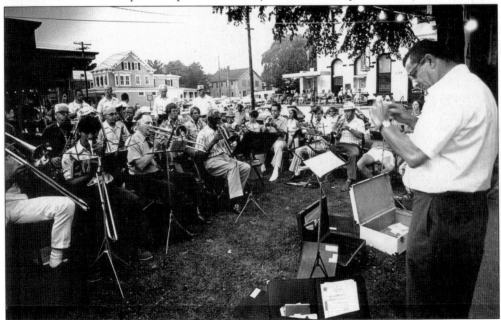

THE GREENPORT CORNET BAND, JULY 4, 1974. Reconstituted after World War II, the group called itself the Greenport Band. It played, then as now, every Friday night in the middle of the downtown village. On the right is Frank Corwin, who led the band for many years. In the rear is Jerry McCarthy, longtime village historian. (Photograph by Peter B. Stevens.)

126

AFTERWORD

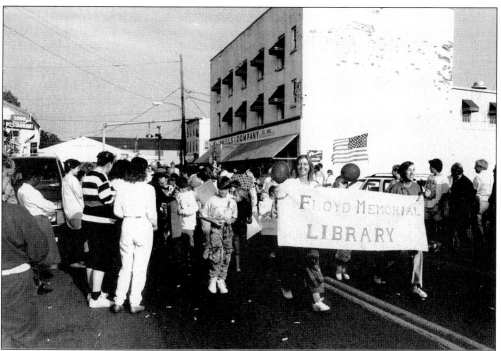

"ONE OF THE BIGGEST PARADES EVER SEEN IN GREENPORT," OCTOBER 1, 1988. Poppy Johnson (left) and then library director Donna Craft carry the banner of Floyd Memorial Library past the Mills Company building, on Front Street, in celebration of the 150th anniversary of the village. In addition to the parade, the USS *Petrel* was in the harbor, a huge fireworks display was held, and a Grease Band Dance and a spirited Anniversary Dance were put on at the American Legion Hall.

A CENTURY AND A HALF, 1988. Greenport Village held a gala to mark its incorporation in 1838. Members of the 150th celebration committee are, from left to right, David Abatelli, Linda Levine Livni, James Monsell, Veronica Diver, James Brehn, Marilyn Shepish, Lillian White, Ruth Yoskovich, Mayor George Hubbard, Pat Forrest, Robert White, Trustee Gail Horton, Kala Langone, and Antonia Booth, Southold historian. Absent from the picture are Pete Harris, Bill Gilooley, Richard Hulse, and Gabe Grilli.

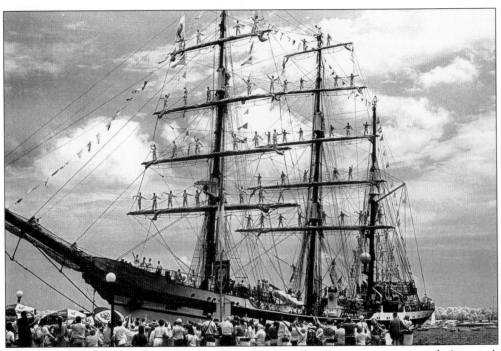

THE TALL SHIPS. The East End Seaport and Marine Foundation, in conjunction with America's Sail '95 and '98, welcomed the ships to Greenport. No one who saw it will ever forget the sight of the *Simon Bolivar*, built in Spain. It was one of the newest of the tall ships, a 270-foot bark from Venezuela. Each fall, the foundation and Greenport's business people put on a splendid marine festival in the village. (Photograph by Gil and Steve Amiaga.)